QUARRYING IN CUMBRIA

David Johnson

AMBERLEY

To Pauline – once a geologist, always a geologist.

First published 2018

Amberley Publishing
The Hill, Stroud
Gloucestershire, GL5 4EP

www.amberley-books.com

British Library Cataloguing in Publication Data.
A catalogue record for this book is available from the British Library.

ISBN 978 1 4456 7246 5 (print)
ISBN 978 1 4456 7247 2 (ebook)

Origination by Amberley Publishing.
Printed in Great Britain.

Contents

Acknowledgements

Illustrations are acknowledged individually and copyright holders are thanked for allowing reproduction. All unattributed images were taken by the author. Every effort has been made to contact copyright holders of historical images in this book. If you believe you have been overlooked, please contact the publisher. If anyone whose name should have been mentioned has been omitted, apologies are offered.

It goes without saying that operational quarries should only be entered by prior arrangement, as should disused sites on private land. Quarries should always be treated with respect and common sense.

Abbreviations

BGS – British Geological Survey (http://geoscenic.bgs.ac.uk/asset-bank/action/viewHome)
BPB – British Plasterboard Industries
CAC – Cumbria Archive Centre
CWAAS – Transactions of the Cumberland & Westmorland Antiquarian & Archaeological Society
LGS – Local Geological Site
MQE – *Mine and Quarry Engineering*
RIGS – Regionally Important Geological Site
SAC – Special Area of Conservation
SSSI – Site of Special Scientific Importance

Introduction

Cumbria's geology is complex. The Lakeland Fells have the oldest rocks, from the Ordovician and Silurian periods, 488–416 million years ago, comprising the Borrowdale Volcanic Group in the central fells, Skiddaw Group beds in the northern, and the Windermere Group in the southern. The Skiddaw and Windermere are mudstone, siltstone, sandstone and slate altered by tectonic processes.

These strata are mostly surrounded by Carboniferous rocks, 359–299 million years old, with limestone underlying the plateau from Orton northwards, curving round to the north-west as far as Egremont, and in southern Furness, Cartmel, Kendal and Silverdale.

Beyond the limestone are later Carboniferous rocks – sandstone and Millstone Grit – from Appleby around the northern fells and the Pennine edge. These are replaced by even younger Carboniferous Coal Measures in the coastal plain between Maryport and Whitehaven. Between the Carboniferous zones are younger Permian and Triassic rocks, 298–200 million years old: the red beds of Penrith and St Bees Sandstones. Locally, where geological forces caused significant chemical or physical change to pre-existing beds, outcrops of less common materials occur, such as Brockram around Appleby and evaporites along the Eden.

Production of slate in quarries in the central and southern fells is well known, but this is just one of many rock types quarried across Cumbria. Some sites were well recorded; others were worked on a part-time basis by local men to meet local needs who saw no reason to document their activities. Some quarries – defunct or operational – are massive in scale, impossible to ignore; others are small, often hidden and unobtrusive, slowly being reclaimed by nature. They all have a story to tell of ingenuity, entrepreneurship, hard physical graft and resilience. Upland weather is rarely kind, and the determination and stoicism of the *stone-getters* should be admired. 'In the past the quarrying industry – rural, unsophisticated and not nationally articulate – simply got on with its job without fuss, coping with a modest demand, generally in a local market'.[1]

Some may equate a quarry with an open working, but many slate quarries had underground workings – *closeheads* – linked to the dressing floors by horizontal *adits* or *levels*. Even if stone was worked underground, the men regarded themselves as quarrymen and not miners, though in smaller workings the term stone-getter may be more appropriate. The Mines and Quarries Act 1954 extended the definition of a

5

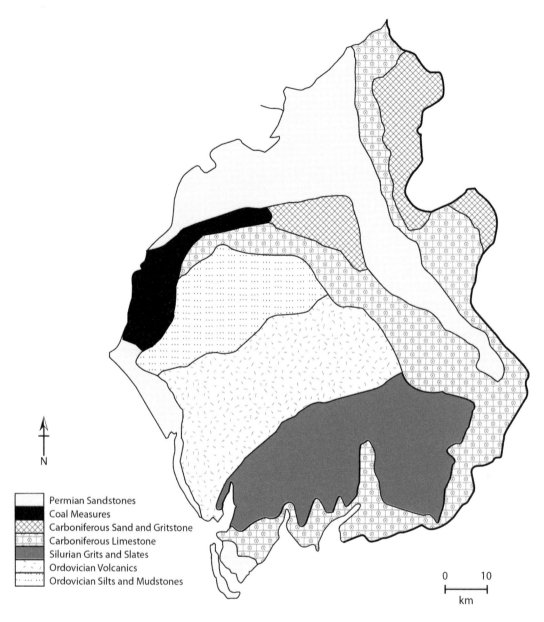

Permian Sandstones
Coal Measures
Carboniferous Sand and Gritstone
Carboniferous Limestone
Silurian Grits and Slates
Ordovician Volcanics
Ordovician Silts and Mudstones

N

0 10
km

quarry to include 'every opening made for the purpose of getting stone'. This legislation clarified the Factory Act 1878, which decreed that a quarry was 'any place not being a mine in which persons work in getting slate, stone, coprolites or other minerals'. Many early workings exhausted reserves accessible by open working and followed suitable veins or beds underground to create *open quarries*. In many cases this decision was made because the quality of underground stone was superior, not having been weakened by millennia of weathering processes. The matter of definition is further complicated when considering quarry products

such as sand, clay, gravel or gypsum, all of which have been extensively worked in Cumbria. Is a sand or clay pit a quarry? In this book, the 1954 definition is favoured.

Any attempt to count the number of disused quarries in Cumbria would be pointless, but the total would be in the thousands; many, especially on the west coast plain, have long since been infilled, levelled off and 'lost', or restored to alternative use. Some have become local nature reserves and some have been left to slowly re-wild in a managed way; others have taken on new roles for leisure pursuits, and others still were simply abandoned.

Two Cumbrian quarry directories from 2014 listed all working quarries, variably stating what quarry products were produced, ownership, and for how long planning consent was valid. One itemised sixteen crushed rock quarries, twenty-eight building-stone quarries and twelve sand and gravel 'quarries', though some were subsequently either mothballed or decommissioned.[2] The second classified quarries by rock type rather than by end product: there was one clay and shale quarry, eleven sand and gravel, two igneous and metamorphic rocks, fifteen limestone, ten sandstone and ten slate.[3]

This book explores quarrying, from a historical perspective, across Cumbria as a whole and for all types of rock worked. Inevitably, there will be a greater focus on certain parts of the county because they had more quarries. Whereas the book attempts to be inclusive, some parts of Cumbria may seem ignored but, for example, the Solway Plain could never have been a major quarrying district because of its geology. Those parts of Cumbria formerly in Lancashire North of the Sands have been included, as has that corner of the county that was part of Yorkshire until 1974, though there is no overlap with this book's sister title on the Yorkshire Pennines.[4] Nevertheless, the quarries included in this book form but a representative fraction of the number that once existed.

Dialect and specialist terms are italicised in their first instance. A national grid reference is given with the first mention of each site as is its geological base – quarries cannot be fully understood without knowing what rocks they worked.

Chapter 1

Early Stone-getting

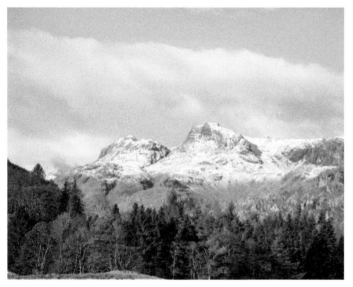

The earliest major exploitation of stone in Cumbria dates from the Neolithic period (3995–3000 BC). Over thirty hand-axe *factories* are known in the Langdale Pikes, including Pike of Stickle, seen here (NY27,07). Hand-axe *roughouts*, worked from Borrowdale Volcanic Group tuffs, were widely traded across England.

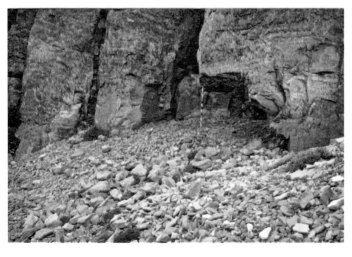

Much of this light-grey stone below Top Buttress is waste material from the knapping of hand-axes, illustrating the scale of operations here. (Jamie Quartermaine/Oxford Archaeology North)

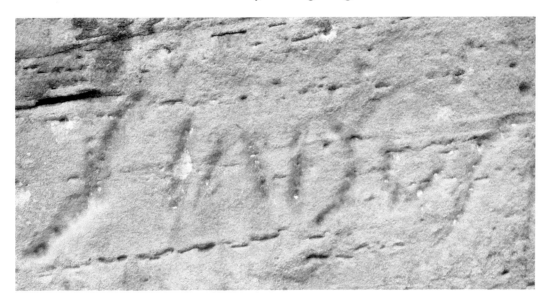

Various sites close to Hadrian's Wall can be linked to Roman quarrying from inscriptions or tooling marks. Triassic sandstones favoured by the Wall's builders were easily worked and shaped. Proven examples include Written Rock of the Gelt (NY5242,5893), Gelt Woods (NY530,585) with twenty-five discrete workings, Wetheral Roman Quarry (NY4667,5350) with three inscribed rocks, Pigeon Crag (NY5301,5786) with one, and Coombe Crag (NY5910,6502) shown here. Etched into the worked face are the words '*SECURUS AP... IUSTUS*'.

South of Dalston, suitable stone was sourced for the Wall and Carlisle Roman fort from Chalk (Shawk) Quarries (NY338,479), stretching along Chalk Beck gorge for over 1 km. Evidence of Roman, medieval and post-medieval open quarries can be seen cut into Triassic sandstone. Below Tom Smith's Leap was the inscription '*LEGIONIS SECUNDAE AUGUSTAE MILITES POSUERENT COHORS TERTIA COHORS QUARTA*', first recorded in 1767.

When Watercrook Roman fort (SD514,907) at Kendal was excavated in the 1970s, a roofing slate was found within the eastern *vicus* (civilian settlement). It measures 310 x 295 mm (200 mm scale). (Kendal Museum, Acc. No. KMA 1979.123. Photographed with permission)

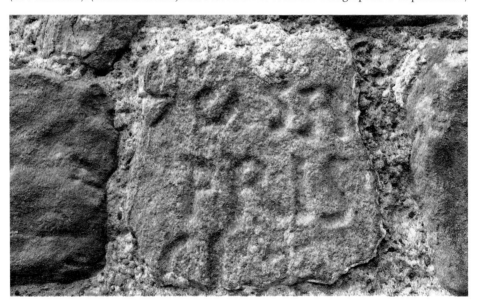

Hadrian's Wall and Roman forts were obvious sources of free, good-quality stone for masons building medieval monasteries and castles. The reuse of Roman dressed stonework, some with Latin inscriptions, can be seen, as here, in the walls of Lanercost Priory (NY556,637), 8 km south-west of Birdoswald Roman fort. This inscription reads '*CASSIUS PRISCUS*', commemorating a centurion. (John Asher)

Furness Abbey's masons (SD2185,7176) had no such access to ready-cut stone, but did have nearby outcrops of red Sherwood Sandstone, from which blocks were shaped and dressed on site. This working lies behind the Abbot's House.

Most medieval quarries were superficial pit-workings rather than the open quarries seen at Furness Abbey, and they are difficult to recognise. The *hills and hollows* landscape, seen here on Wan Fell (NY5245,3465), typifies medieval stone-getting: the hollows were shallow quarry pits, the hills piles of waste, created as the stone-getters moved around their allotted area, exploiting Penrith Sandstone.

Chapter 2

Quarrying Slate

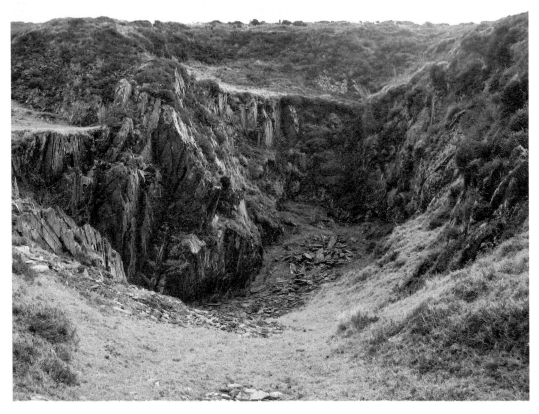

There are several quarries on Bank House Moor like this one (SD2399,8060), each connected to an old bridle road by graded cart tracks. By 1850 they were all disused. Extraction of Brathay Formation siltstone and mudstone was entirely by hand tools.

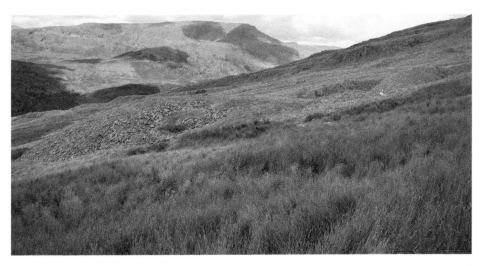

Yolk (Yoke) Quarry (NY5300,0559), 480 m above ordnance datum (AOD), was connected by a 1.5-km-long track to Garburn Road. Small and technologically simple, remote quarries like Yolk often started as speculative ventures by people known as *adventurers*: some succeeded, others failed. Here, there is some infrastructure with two *riving* sheds and a *bait* cabin (shelter). Yolk worked Woundale Tuff beds.

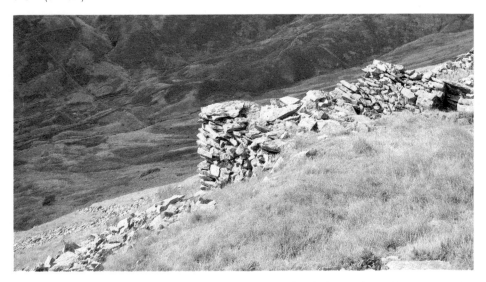

Lowther Estate correspondence from the 1870s considered the wisdom of anyone taking on the lease of the proposed Scandale Fell Quarry (NY3877,0838), despite its rich seam of Coniston Green Slate (tuff). The quarry that was opened up is at 610 m AOD, 7 km across wild terrain from Ambleside, its intended market. The Estate was advised to offer it on a two-year rent-free lease. In November 1876, Thomas Mackereth took the bait. He was an accountant in Ambleside and was required to keep a minimum of four men in 'constant employment', except in bad weather. The lease covered a huge area between Seat Side and Snarker Moss. In February 1877, the conclusion was reached that it 'may not prove worthwhile', as by the end of 1876, output of slate was a meagre 28 tons.[5] The hillside is so steep that even packhorses were not an option; manpower was the only means of taking slate away.

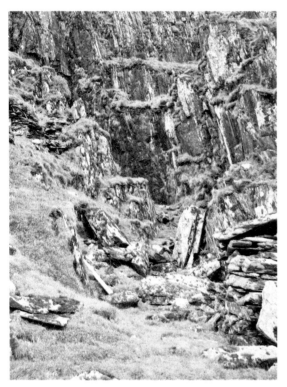

Equally impossible to access were two early workings, both seeking slate from Seathwaite Formation beds, below Star Crag in Kentmere. The lower of the two (NY4424,0702), 460 m AOD, is quite inaccessible, with no trace of any path or track and with a very steep descent to the valley floor. The higher quarry (NY4409,0690) defies comprehension, being at 545 m; though separated from the dressing floor at the lower quarry by a short distance, the upper half of this route has a gradient of 1 in 2. Inevitably, workings like these have no written history, but one can but marvel at the stone-getters' resilience and sheer bloody-mindedness. For sure, they needed a good head for heights and perfect balance.

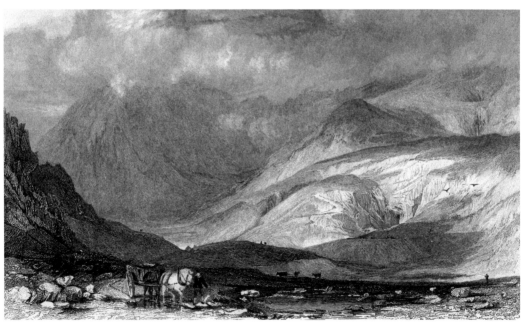

Once down onto more sensible ground, slate was dispatched from upper Kentmere by horse and cart, as depicted in this engraving. (*Kentmere Head, and Slate Quarries, Westmorland.* Engraved by Samuel Bradshaw from an original study by the painter-architect Thomas Allom, 1832–35)

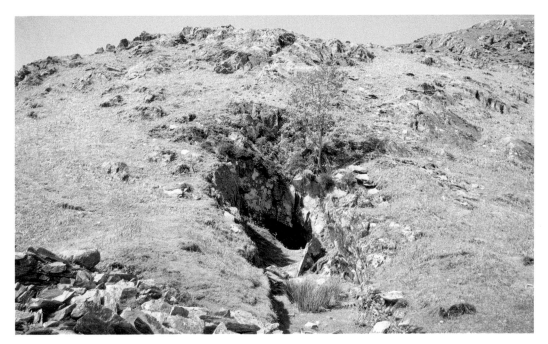

At the head of Dunnerdale, two concentrations of slate quarries worked Borrowdale Volcanic Group andesite. Below Stickle Pike, two quarries were given up before 1850. The lower is an open quarry (SD2158,9283); the upper has a ruined two-cell cabin/store and an open riving shed near the entrance to a 20-m-long level, which leads to a closehead.

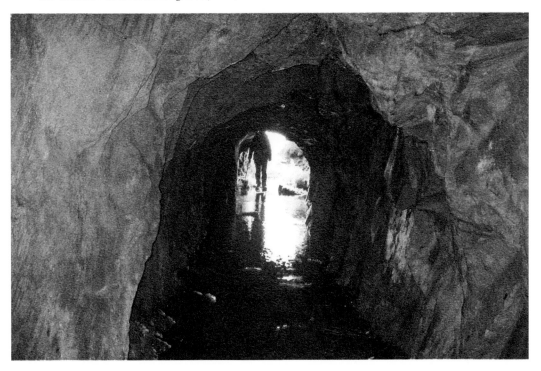

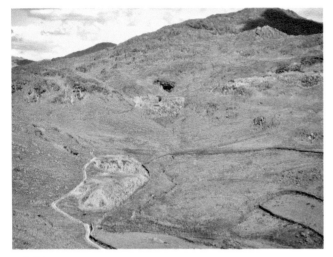

Across the valley from Stickle Pike lie Stainton Ground Quarries (SD22,93), comprising a number of open workings and levels, one of which still has the imprints of sleepers from its horse-drawn tramway, and all of which accessed closeheads. The scale of the spoilheaps here, as in all slate quarries, is prodigious, as 85 per cent or more of the quarried rock was waste.

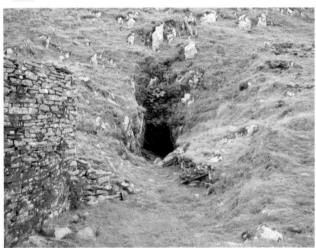

Caw Quarry (SD2288,9480), 380 m AOD, lies at the end of a well-engineered, 600-m-long cart track and consists of a single waste pile and level, which still has the remains of wooden tramway rails and a wooden *stee* (ladder). The level leads to a closehead.

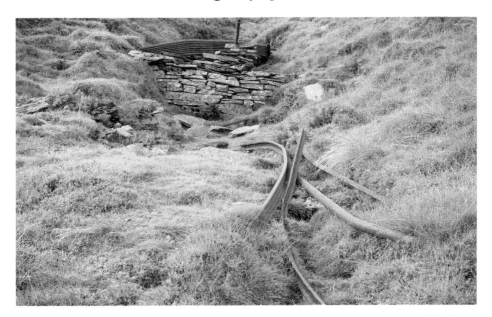

High above Brothers Water, Caudale Quarry is composed of open workings and levels on both sides of the fell. It was a major concern, operated for many years by Thomas Shaw & Sons. On the east side of the fell are remains of a cabin and five riving/*dressing* sheds, as well as two levels and a shaft dropping into a level (NY4083,1088, at 530 m). Abandoned tramway rails and compressed air pipes emphasise the industrial nature of quarrying here.

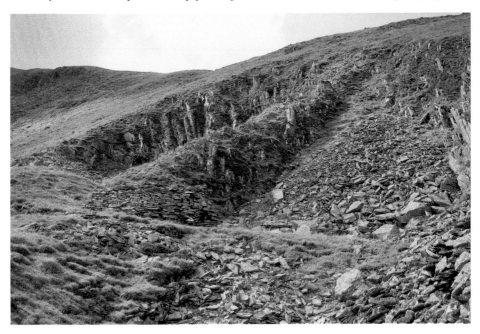

Above that complex is another (NY4082,1084). At the southern end is a large open working with a near-vertical face and a rock-cut level at its base, but this was pushed only 8 m before work stopped.

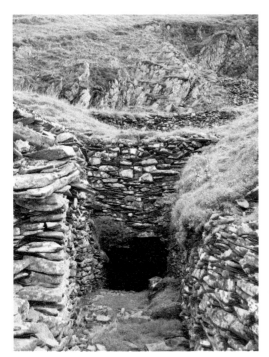

On the western side of Caudale Fell, linked by a trackway from the east, is another large open quarry (NY4068,1071), 530 m AOD. This, too, has a level that was walled and corbelled as it drove beneath the quarry floor, now ending after 18 m in a roof collapse. A short incline led up from the quarry to the dressing floor. Caudale exploited Esk Pike siltstone for what were described in 1812 thus: 'Much blue slate, of an excellent kind,' was quarried mainly for roofing.[6] Caudale Quarries worked from the late eighteenth century, expanded dramatically through the nineteenth, closed in 1914, and re-opened in 1932, which is when compressed air was used for driving levels.

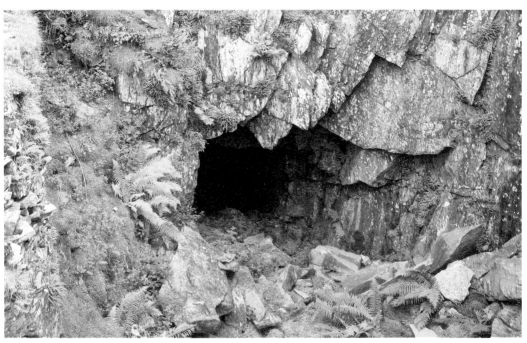

Equal to Caudale in scale and ambition are quarry complexes in Troutbeck Park that worked Woundale Tuff andesite for roofing slate. Rare for historical quarrying is a range of documentary material, for the eighteenth century in particular.[7] Low (Park) Quarry (NY427,062) had open workings, several buildings, internal tramways and various levels, but by 1859 it was out of use.

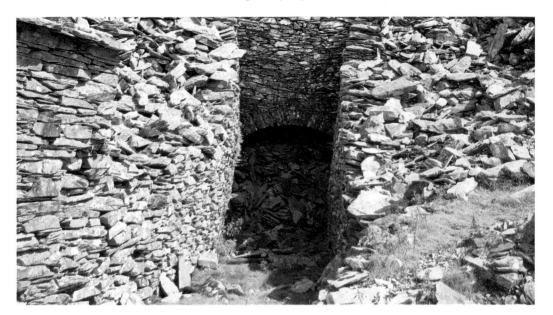

High Park Quarry (NY429,069) rises in six tiers from 330 m AOD, where the main offices were sited, to over 400 m, where there is a dressing shed and a cabin. Four levels are visible, including the collapsed one shown here with its high *judd* (retaining) walls and vaulted roof. The scale of work is breathtaking and it was operational, with periods of inactivity, from *c.* 1720 to the early twentieth century.

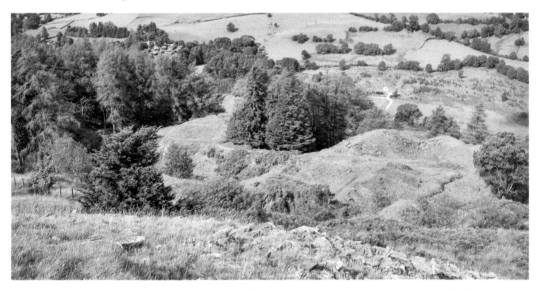

Further down Troutbeck Valley, Applethwaite Quarry (NY422,034) was worked in the late nineteenth century by G. H. Robinson of Bowness, who also worked Troutbeck High, cashing in on the tourist-inspired growth boom along Windermere. Applethwaite is recorded from 1707, and possibly from 1650.[8] It worked andesite for roofing slates, flags, flooring, sills, lintels, gateposts, troughs and edging stone. It was able to produce a wide range of bulky products as it had much better access and was nearer to Windermere than High or Low Quarries. It was defunct by 1914.

The high fells south of Haweswater had two major centres of operation. Mosedale Quarry (NY494,097) is composed of seven discrete open workings along the 500 m contour, each with its own waste heaps, sheds and dressing floors. It, too, worked Woundale beds, mainly for roofing slate sent away eastwards through Swindale and Wet Sleddale. By the 1920s it had closed.

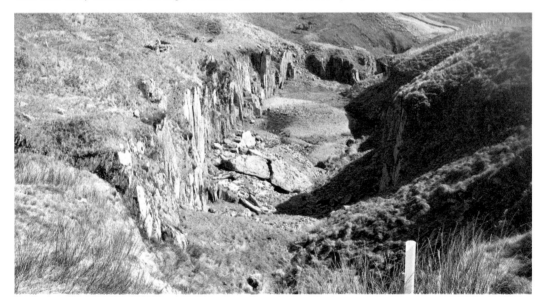

Wrengill Quarry (NY474,085), 2 km south-west of Mosedale Quarry, is impressive for its sheer size, complexity and longevity. It worked andesite for slate from at least 1724 to the 1940s. In 1835 Wrengill was 'famous for the quality and quantity of fine blue slate' it produced.[9] A record from 1851, however, said it had seen its best days seven decades earlier and, because of its remoteness and geological challenges, slates 'had not been wrought for several years'.[10]

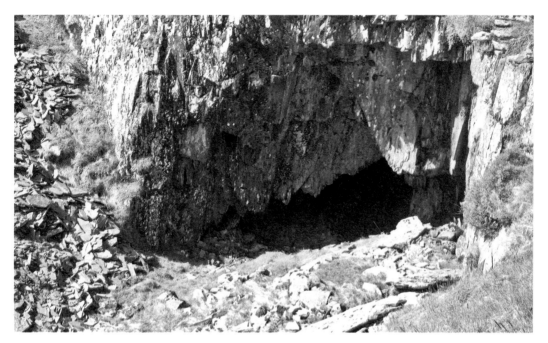

The 1835 tribute is also contradicted by a traveller's account from 1825: 'What an excavation! Now deserted! Since [the traveller's guide] could remember, he had known them *export* slate through Mosedale and Mardale to a great extent.'[11]

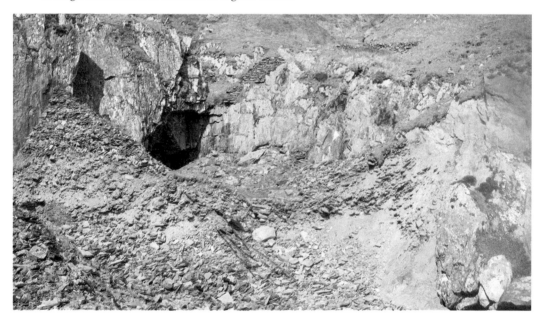

In 1946 work began to extend an existing tramway south-eastwards along the contour to the top of what was to be an *aerial flight* (overhead ropeway). It is obvious on the ground that the tramway bed was never completed and the flight never installed. In 1926 a flash flood caused havoc at Wrengill.

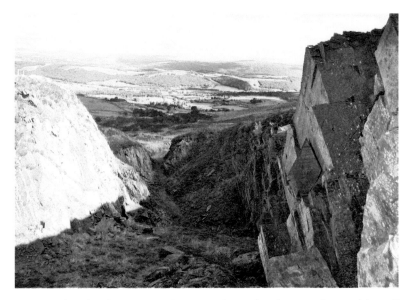

Nowhere in Cumbria has been quarried on an industrial scale more than Kirkby Fell, whose massive waste heaps stand prominent in the Furness landscape. Over time there have been at least fifteen discrete quarries here, working Wray Castle blue-grey slate – the now-famous Burlington Slate. Gawthwaite High Quarry (SD262,842) is a deep linear slit constrained spatially and forced to go ever deeper into the hillside. There is ground evidence that work here began towards the upper end of the quarry, where there are remains of early buildings. The quarry had exhausted its reserves by *c.* 1920 but was briefly re-opened in 1962.

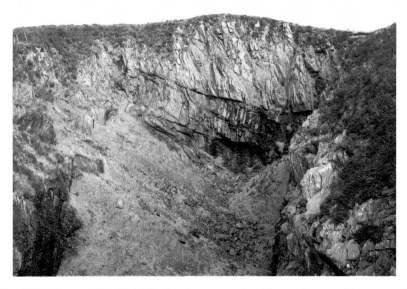

Tumbler Hill Quarry (SD257,842) also has ground evidence that working started at a higher level than the present quarry floor: a cart track is now stranded at the top of a vertical drop. The only means by which stone was removed from the later quarry was by crane. Tumbler Hill peaked in the nineteenth century.

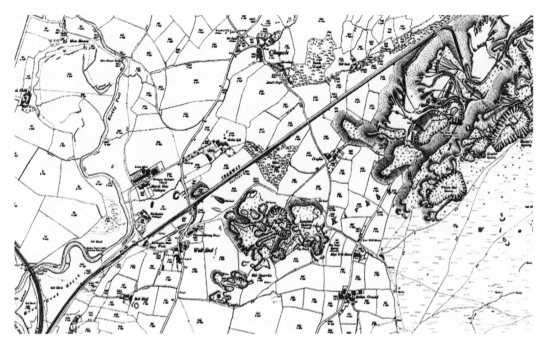

What is now the 1,500-m-long Burlington Stone complex started as a number of discrete workings, each leased from the Burlington Estate, with quarrying pre-dating 1700. In 1843 the Estate brought them all in-house, working them as Burlington Slate Quarries. (OS 25 inch, Sheet XI.5, 1891)

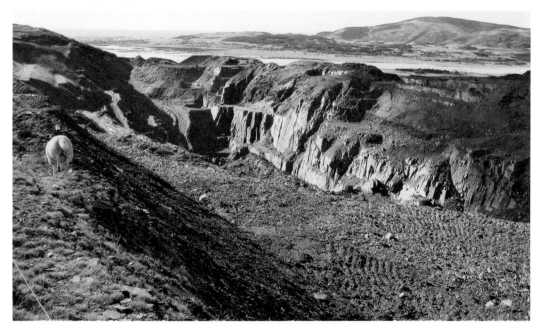

The individual quarries worked using the *bench* system, with many tunnels driven to access better quality stone or to connect one quarry hole to another.

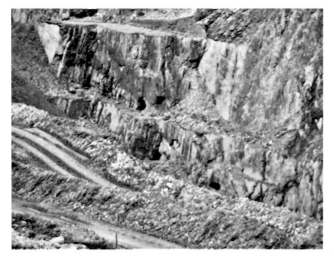

Some of the tunnels have been truncated by later working, as seen here. Whereas High Gawthwaite's maximum annual output was 25,000 tons, Burlington's exceeded 800,000, pre-1843.

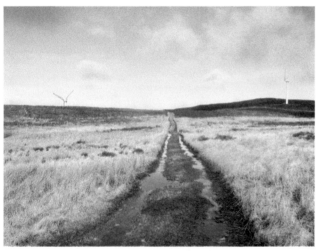

Slate was dispatched from Kirkby Fell by three routes: by cart to Greenodd; along Kirkby Slate Road to Ulverston; or down a cart road to Kirkby Pool at Sand Side. The latter was later replaced by a 2-km-long inclined plane laid alongside the road.

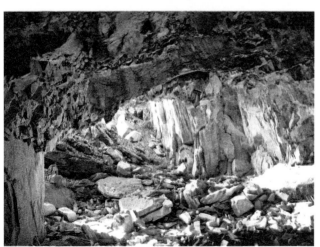

Four slate quarries in Borrowdale and Tilberthwaite were run between the World Wars by one company, each marketing a different type of slate. Grange Fells Quarry's 'Best Deep Green' sold at 165*s* per ton in 1933, as did Broad Moss Quarry's 'Dark Sea Green', while Sty Rigg Quarry's 'Light Sea Green' cost 170*s*. Dalt Quarry's were not given.[12] Sty Rigg (SD3115,0191), seen here, has a closehead and an open quarry, operational from the early nineteenth century at least.

Chapter 3

Quarrying Non-Slate Volcanics

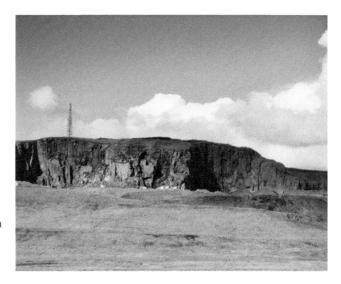

Shap Granite has been worked for centuries and its distinctively speckled-pink stone was polished and shaped for facades, columns and monumental masonry, as well as more humbly for kerbstones and setts. The massively bedded granite is still worked at Shap Pink Quarry (NY558,083), which was opened in 1864 by D. D. Fenning, producing these *dimension stone* products. From 1875 it was operated by the Shap Granite Company. This view shows the quarry face.

Blocks were transferred from Shap Pink on a standard-gauge railway to Shap Granite Works, 3.5 km to the north. In 1953 the rails were lifted and the track was converted for use by dump trucks.

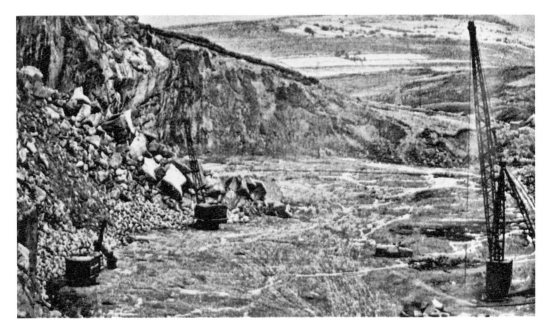

Around 1882, Shap Pink installed plant within the quarry to crush waste stone that was mixed with cement at the Shap Silicated Granite Pavement works for paving, sills, steps and cisterns. Undresssed blocks, up to 10 tons each, were dragged across the quarry floor to the dressing area by these two Henderson derrick cranes with 34-m-long jibs. (MQE 25, 1959)

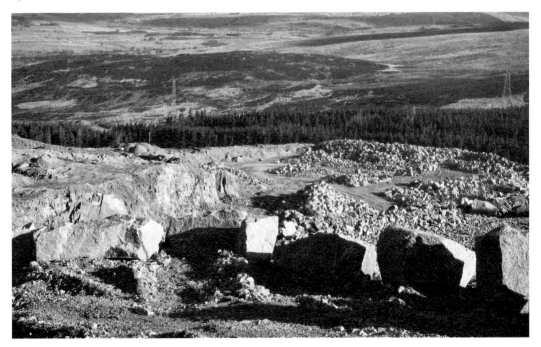

In 2014 Shap Pink was mothballed but revived two years later, concentrating on crushed stone. This view looks from above the face to the stocking ground. Consent is valid to 2042.

Threlkeld Granite Co. opened Threlkeld Quarry (NY327,244) in 1864 to exploit Threlkeld Microgranite. By 1878 the quarry was producing ballast for the Cockermouth to Penrith railway and in the 1890s it further expanded to supply stone for the new dam at Thirlmere. The quarry also produced crushed and coated roadstone and, until 1936, 'Granite Concrete Paving' blocks, as well as ballast for the Lancaster to Carlisle railway.

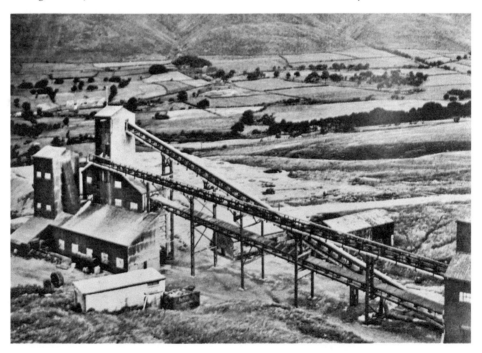

Threlkeld closed in 1937, re-opening in 1949 with the installation of a new crushing, screening and tar-coating plant, seen here. From 1949 it employed thirty drivers, seven plant operators, five excavator operators and two drop-ball navvy operators, but only five stone-getters. The quarry was taken over by a multi-national in 1966 and closed in 1982. (MQE 26, 1960)

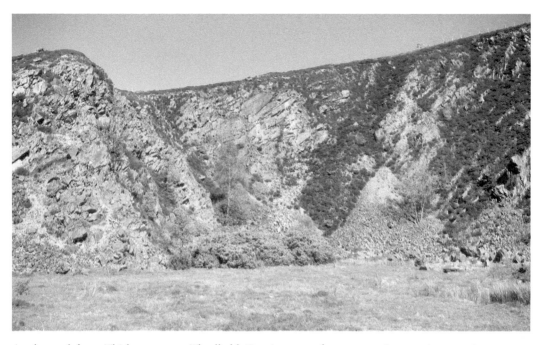

As demand from Thirlmere grew, Threlkeld Granite opened up new microgranite quarries to the south – Hilltop and Klondike or Spion Kop (NY3210,2328 and NY3205,2300). These were linked to Threlkeld's plant by a 2-foot-gauge tramway.

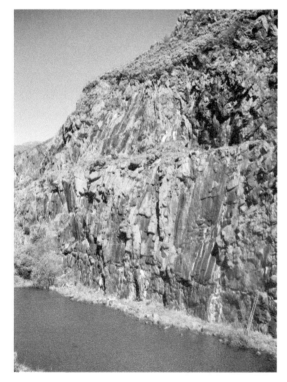

Continuing buoyant demand saw the company extend the mineral railway even further south to open up Bramcrag Quarry (NY319,219) in the 1900s. One workman here, Thomas Glasson, met a sad end: he was fatally pinioned by a 6-ton block while working as a *popper*, breaking large blocks up by handheld machine. The mineral line was lifted in 1937 and dumpers were used instead to transfer stone to Threlkeld's crushing plant.

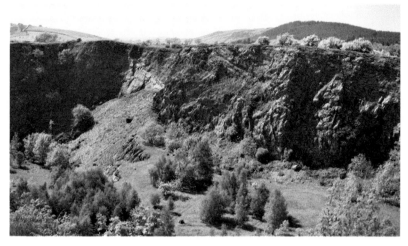

In 1936 Threlkeld Granite merged with the Cumberland Granite Co., which ran Close Quarry (NY174,308), exploiting Embleton Microdiorite. Close Quarry had worked since at least 1860, when it closed, but it was re-opened in 1907 by Cumberland Granite, which was trading as Embleton Quarries by 1923. At this time there were four tramways within the quarry and a continuous-rope incline, installed in 1912, down to the plant area near the main line railway. By 1947 the tramways had been taken up and replaced with dumpers. To access better quality rock underground, a tunnel was driven into the main quarry face in 1919, but after the two companies merged in 1936 to form the Keswick Granite Co., Threlkeld was closed, with all production concentrated at Close Quarry, though the situation was largely reversed in 1949. Six men were retained at Embleton, however, producing *pitching* and *penning* stone.

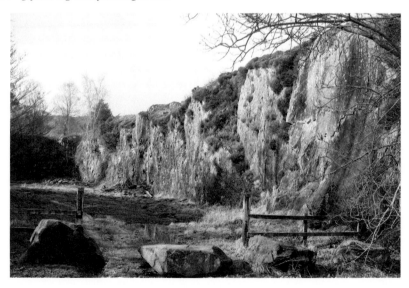

Lower Devonian microgranite was worked in Brown Howe Quarry (SD2886,9093), where a vertical igneous dyke cut through Silurian Bannisdale Slates: the quarry is long and narrow, following the dyke, with faces 10 m high. It was operational by *c.* 1900 and abandoned by the 1970s; it now has LGS status.

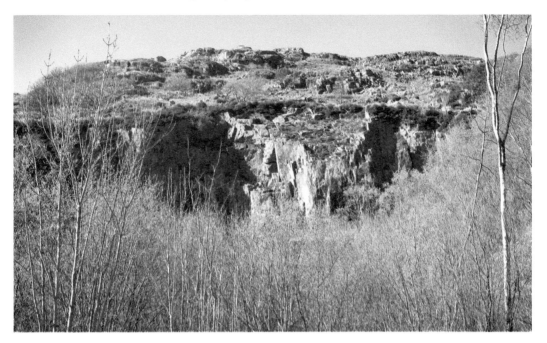

Devonian beds – Eskdale Granite and granodiorite – were quarried at Beckfoot Quarry (NY1640,0035). True (pink) granite is seen in the eastern quarry face, with darker granodiorite in the western.

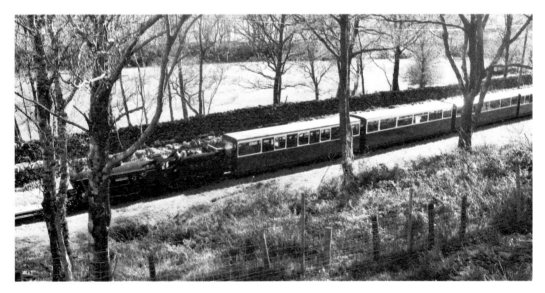

Beckfoot started its commercial life in 1901 using the then 3-foot-gauge La'al Ratty Railway. By the 1920s the quarry was operated by Narrow Gauge Railways Ltd, which sent stone downline to the crushing plant at Murthwaite to make ballast and aggregate. Beckfoot was taken over by the Keswick Granite Co. in 1946 but closed in 1953, by which time only four men worked here. In 1955 the company applied for consent to re-open it and to build plant within the quarry, but it did not re-open.

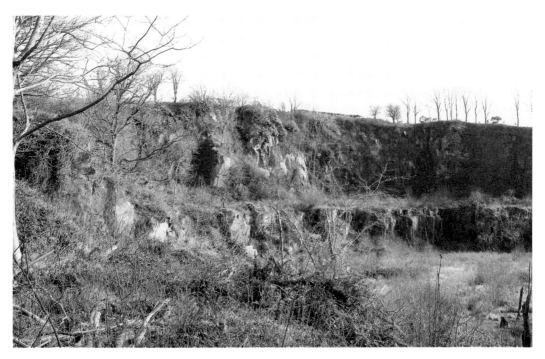

The same strata were worked in Broad Oak Quarry (SD1125,9440) for roadstone from the late nineteenth century until 1946. It is now an SSSI.

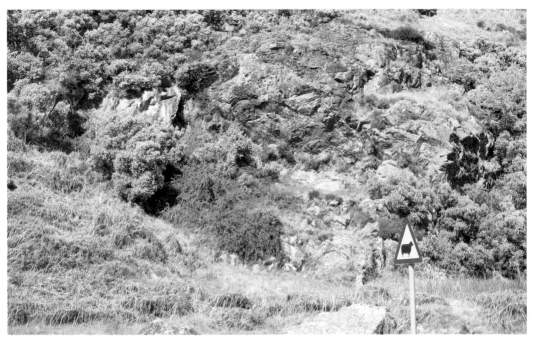

On an altogether different scale, volcanic gabbro was worked at Mosedale Moss Quarry (NY3565,3254). It only had a short life and was for local use. Despite its small size, it is a RIGS.

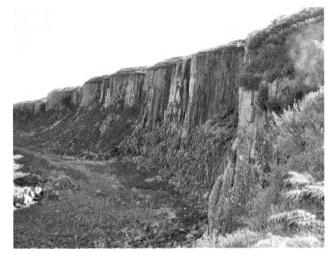

Midgeholme Quarry (NY6265,5800) exploited Great Whin Sill microgabbro for crushed stone and ballast. The sheer size of the disused quarry speaks of the volume of rock taken away: the face is approximately 35 m high and was cut 60 m back into the hillside for a length of approximately 300 m.

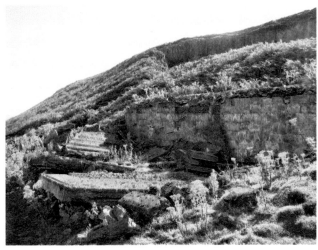

Midgeholme was accessed by a long inclined plane, and bricks from a demolished building at the incline top date them to *c.* 1920–40, when the quarry was in full production.

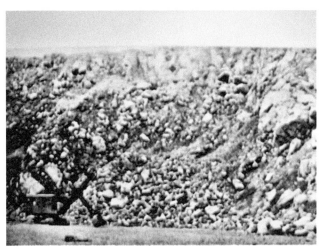

Ordovician andesite has been worked in Shap Blue Quarry (NY565,105) since the late nineteenth century with the original quarry east of the A6. The 'new' quarry was working before 1899, linked by a tramway tunnel under the road to the Granite Works. (MQE 25, 1959)

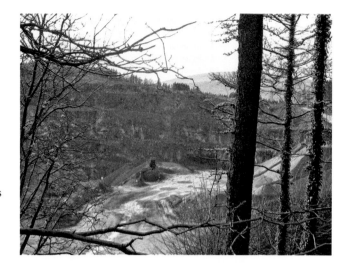

Ghyll Scaur Quarry (SD17,82) began in the 1930s to exploit the andesitic tuffs that give this quarry the accolade of having the highest grade roadstone in England. Its consent is valid to 2045.

In St John's in the Vale, Yew Crag Quarry (NY3155,1936) was also a roadstone quarry working green andesite within the Crags Tuff Member. It opened at the end of the nineteenth century but has long since lain idle.

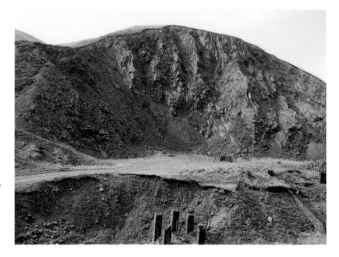

Knock Pike Quarry (NY6870,2850) worked ignimbrites within Knock Pike Tuffs for high-quality aggregate. It began in the early twentieth century (pre-1920) and was still working in 1992. Remains of a cabin and loading bays survive.

Chapter 4

Quarrying Limestone

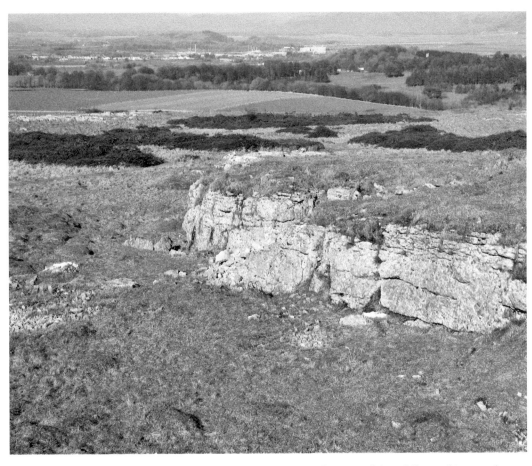

Birkrigg Common has field evidence of stone-getting ranging from small lime kiln workings and those for obvious local use to two substantial quarries. Mapping from the 1850s identified eleven quarries, or 'old quarries', and five kilns. This working (SD2849,7427), in Urswick Limestone high on the fell, is approximately 100 m long but only 1.5 m high, and is split into discrete bays, suggesting it was worked independently by several individuals.

34

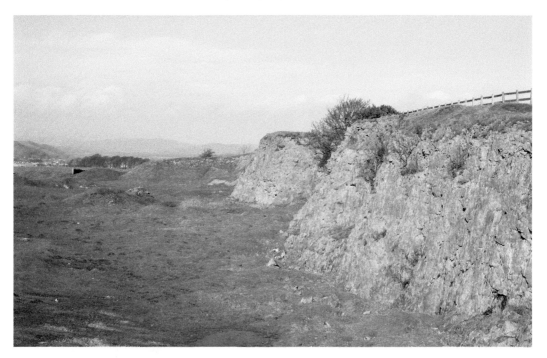

At the northern foot of the Common (SD2815,7467) is this large quarry, worked from at least the 1880s into the twentieth century, exploiting Park Limestone beds for use in blast furnaces.

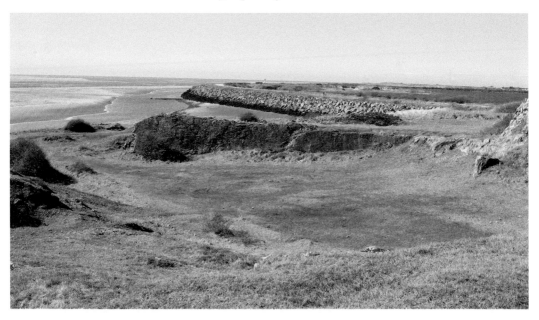

Carboniferous Limestone was quarried extensively at Millom for the town's former iron and steel industry. Hodbarrow Quarry (SD1825,7813) started life feeding the large twin-kiln called 'Hodbarrow Limekilns', whose ruins can still be seen; later stone from here was used as flux in the early days of Millom's iron industry.

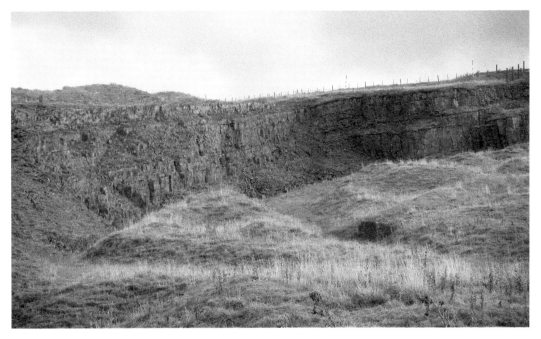

There were many quarries either side of Hartside Pass, mostly feeding lime kilns. Greenfell Quarry (NY6318,4196) is the largest of the group and had by far the largest twin-kiln, processing Scar Limestone beds. In 1898 it was described as 'Old Quarries'. The kiln still partly stands.

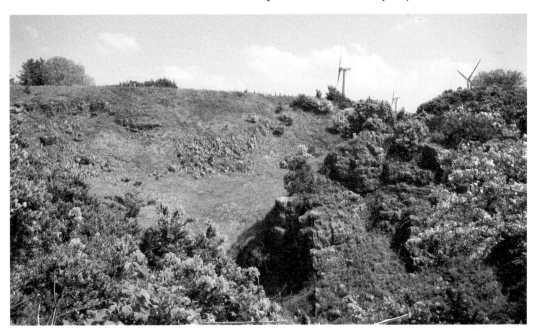

Wharrell's Hill Quarry (NY1707,3815) comprises three quarry holes, which worked Fifth Limestone to feed a large masonry kiln. Like the majority of proto-industrial operations, this one was abandoned by the 1890s.

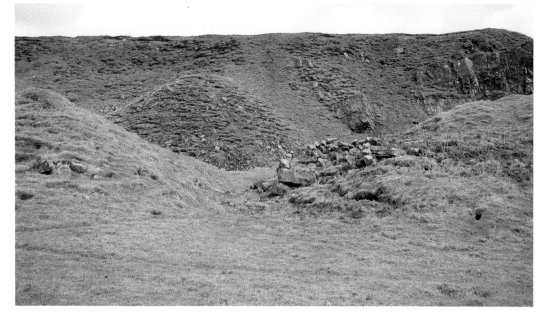

There were several substantial quarries along the Pennine edge, mostly associated with commercial or estate lime kilns. Croglin Quarries (NY581,484) saw its heyday in the early to mid-nineteenth century. In addition to burning lime, these fossil-rich Yoredale Limestone rocks were cut, polished and marketed as 'marble'.

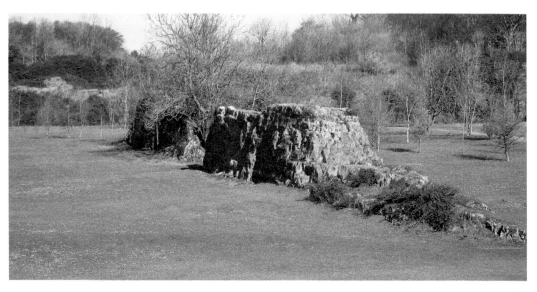

Kendal Fell has seen several quarries operational at different periods, the most recent of which (SD507,926) has been effectively dormant since 1992. Large-scale quarrying of Carboniferous Limestone was initiated under the Kendal Fell Enclosure Act 1767, which granted common-holders rights to take stone and 'burn the same into lime'. These rights were extinguished in 1849 by an Act of Parliament and active limeburners were obliged to pay royalties. A further Act of 1861 imposed tighter regulations, including quality control.

One of the commercial lime-burning families on Kendal Fell in the old quarry was the Robinsons. John was listed in the Kendal Fell Trust account books from 1856 and Joseph up to 1872. This 1870 invoice itemised sales of lime to Richard Parker of (Shap) Borrowdale, a journey of 24 km each way. (David Johnson)

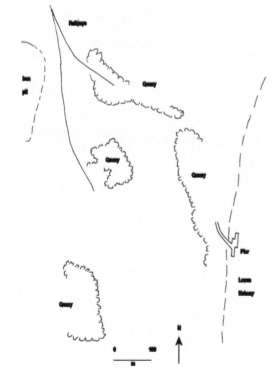

Plumpton Quarries were leased from Plumpton Hall Estate from 1896 by the North Lonsdale Iron & Steel Co. of Ulverston to exploit Dalston Beds Limestone for lime, 'small lime' and crushed stone. The four quarries were still operational in 1923, with a rail link from the main line.

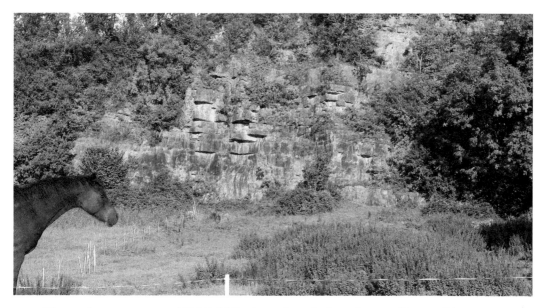

The southernmost quarry (SD310,782), shown here, is the only one still accessible.

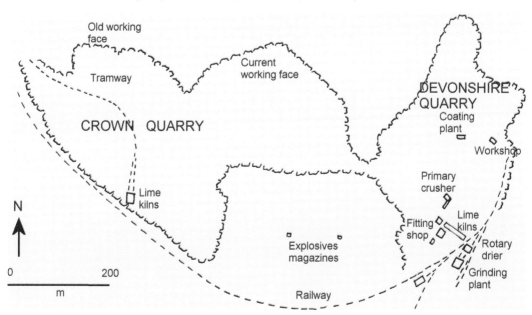

Stainton Quarries started life as two discrete workings: Devonshire Quarry (SD249,728), leased from the Devonshire family's Holker Hall Estate, originally worked Urswick Limestone that was dressed, polished and marketed as 'Ulverston Marble' through the second half of the nineteenth and early twentieth centuries; and Crown Quarry (SD244,728), which was opened up in 1868 when the Stainton Branch Railway was laid by Barrow Quarries, a subsidiary of Barrow Haematite Steel Co. The line was soon extended to Devonshire and the two slowly merged into one huge quarry. Crown was closed in 1942 and it was only in that year that mechanisation was introduced to Devonshire.

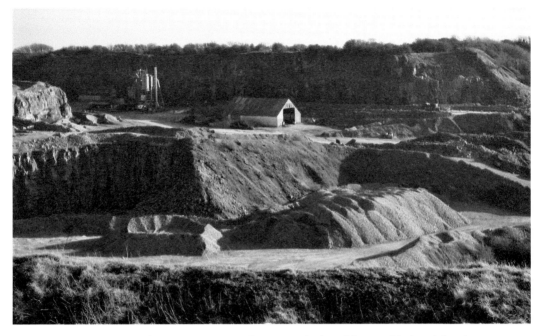

Stainton Quarries now market aggregate, coated stone, agricultural lime and industrial carbonate. Consent is valid to 2042.

The earls of Carlisle's Naworth Estate had extensive coal mining and limestone quarrying interests at Forest Head in the North Pennines. Clowsgill Quarry and Limeworks (NY590,591) had closed by 1900, but Howgill Quarry (NY585,577), shown here, operated well into the late twentieth century, though lay dormant by 1999.

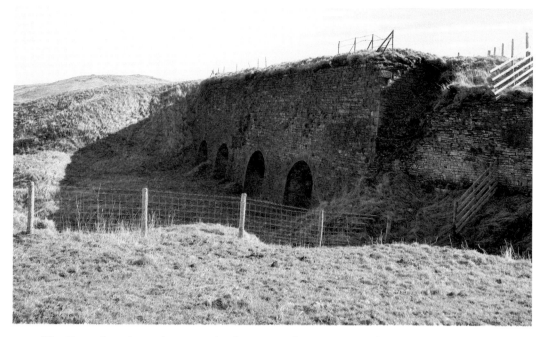

The Estate leased out these quarries from 1891 but wrote into the contracts that farm tenants were collectively to receive annually 5,000 tons of 'Best Broad Lime', free from limeash and small-lime. This kiln battery in Howgill Quarry processed Stainmore Formation limestone.

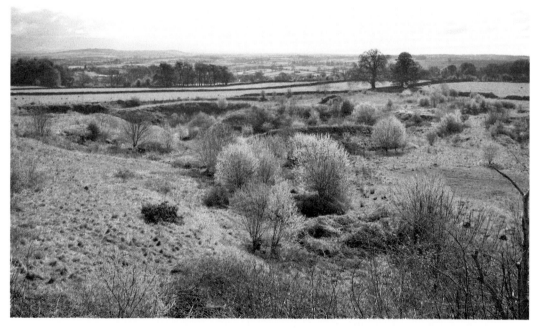

Fluskew Lodge Quarry (NY473,281) used Yoredale Group limestone for producing lime in a large (long since demolished) twin-kiln on the east side of the quarry, from the late eighteenth or early nineteenth century. By 1898 that quarry was described as disused.

Work at Fluskew edged westwards and a new, tall (now ruinous) twin-kiln was erected on the quarry's north side; this was replaced by the massive battery of kilns that still stands, along with the remains of crushing plant, offices and workshops. Mapping from 1960 named it as Flusco Lodge Quarry.

Just north of Fluskew Lodge was another pair of large quarries. Flusco Quarry (NY460,292) worked Lower Little Limestone for crushed stone and lime. Construction of the Penrith to Cockermouth railway, opened in 1865, followed a huge loop round this and the neighbouring Blencowe Quarry (NY463,301), and led to a huge boost in output at both. Joseph Harrison owned 'Harrisons Limeworks' at Flusco from at least 1905 and he was a pioneer in the technology of crushing limestone to dust. He had a eureka moment, noticing that grass alongside roadways dressed with crushed limestone grew more profusely, so he perfected a new method of pulverising the rock.[13] This act alone was largely responsible for burned lime being replaced as a soil improving agent by pulverised limestone dust, which was much cheaper. (Jessie Pettiford)

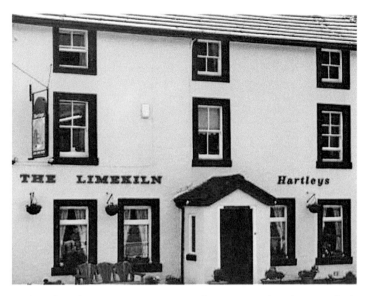

Exploitation of Carboniferous Limestone at Brigham was undertaken in Ellerbeck Quarry (NY083,307) and Brigham Quarry (NY087,306), both substantial operations originating in the nineteenth century, though Brigham Limeworks was only established in 1929. The Limekiln (NY0835,3070), a former public house between the two quarries, is testament to the importance of lime burning here. (© John Holmes 2003. Licensed for re-use under Creative Commons Licence)

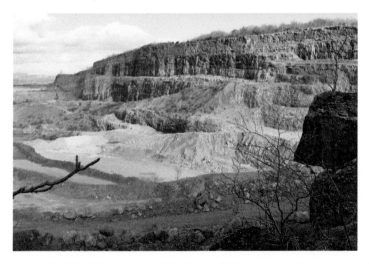

Sandside Quarry (SD482,806) was established in a fully commercial manner by Northern Quarries Co. to produce ballast, crushed stone and, later, pulverised limestone dust, though it had been worked much earlier for lime burning. A new masonry-built kiln battery was erected *c.* 1885 with adjacent rail siding for direct loading of lime. In 1925 the company added a 'Quarrite' facility here: invented *c.* 1898 by the company's James Ward at their Trowbarrow Quarry across the county boundary, it proved a very successful way of coating roadstone. Sandside now markets agricultural lime, crushed and coated stone, with consent valid to 2020, though little actual quarrying takes place here now.

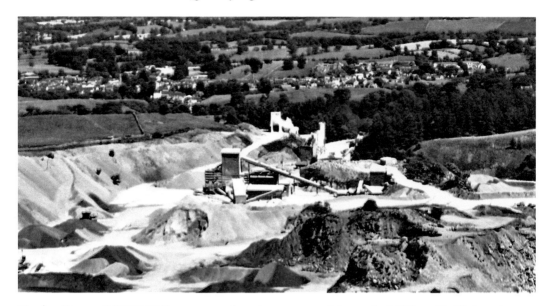

Hartley Quarry (NY790,084) was opened up in a commercial way in 1927, as Sir Hedworth Williamson's Limeworks, to replace its quarry and limeworks near Sunderland. The company needed high-quality Carboniferous Limestone for ironworks in the North-East. Hartley Quarry had a rail spur from the South Durham & Lancashire Union Railway so was ideally situated. Two Priest kilns were installed, one in 1927 and the other in 1936, along with a crushing, screening and hydrating plant. The kilns had gone by 1996 and the quarry focussed on crushed stone; it was mothballed in 2008 and put on the market as a working quarry. However, consent is valid to 2042.

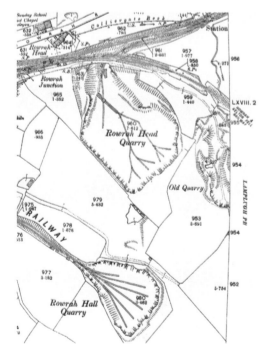

There was a notable concentration of quarries working Eskett Limestone beds, all to feed iron and steel plants in West Cumbria. Rowrah Quarry (NY058,182) was originally two separate open quarries operational from 1888 to 1944, worked by the Workington Iron & Steel Co. In 1936 the two quarries were physically joined. (OS 25 inch, Sheet LXVIII.1, 1925)

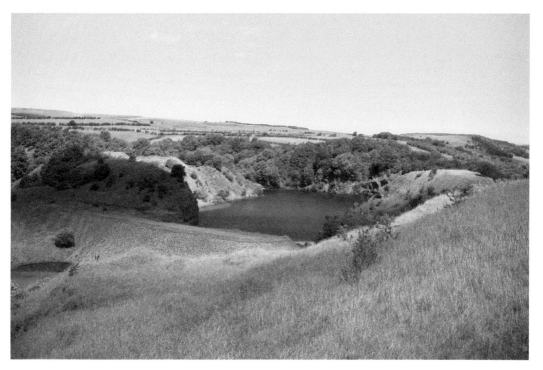

Rowrah closed *c.* 1980 and is now either flooded or overgrown.

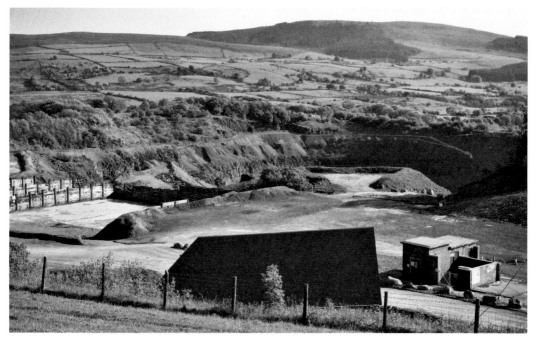

The quarry owners hope to open Rowrah up again as reserves at their existing Eskett Quarry (NY054,168, formerly Postlethwaite's and Jackson's Quarries), seen here, are almost exhausted.

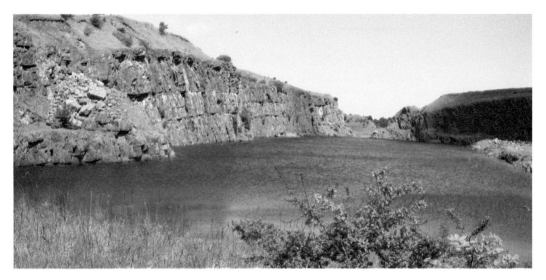

Rowrah Quarry was physically linked to Salterhall Quarry (NY059,175) to the south, which is also now flooded. Both were deep quarries with an internal network of tramways and external rail connections. Salterhall developed in the late nineteenth century and grew to be over 500 m long, supplying lime to Cleator Moor Ironworks until 1927.

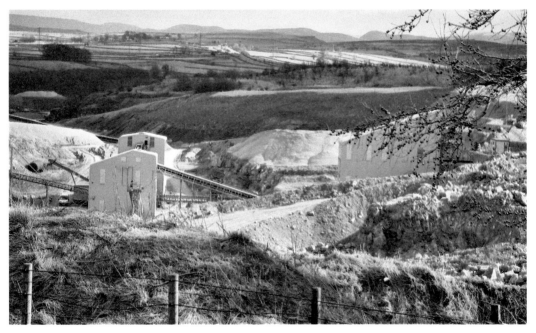

Shapbeck Quarry (NY54,18) was opened in the 1930s, leased from Lowther Estates, from 1943 to 1958 by Harrisons Limeworks of Flusco. Shapbeck produced crushed and pulverised limestone as well as lime, and Harrisons wanted it to meet increased demand from Ravenscraig Steelworks. By 1958 the quarry had increased its area by about a half and since then it has expanded enormously. Its five lime kilns were decommissioned *c.* 1980; it now concentrates on crushed stone products and supplies Tata Steel's kilns at Shap. Consent is valid to 2042.

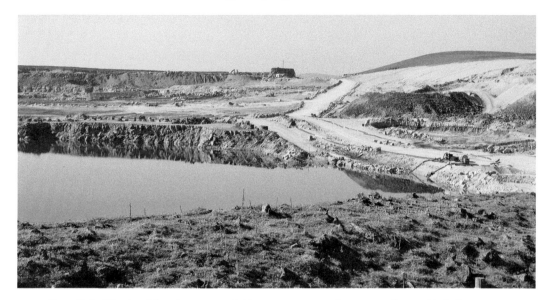

Shap Fell (Hardendale) Quarry (NY59,14) was opened as recently as 1960 because Messrs Colvilles, which owned Clydeside Steelworks, sought extensive limestone reserves of their own. It, too, was leased from Lowther Estates. As Colvilles were swallowed up by British Steel, then by Corus, and now Tata, Shap Fell kept the lime kilns at Shap going until recent years, when environmental concerns surfaced in a big way. In 2008 Tata lodged an application to resume quarrying by deepening it.

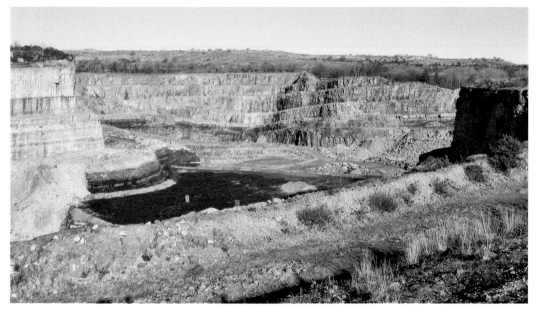

Holme Park Quarry (SD537,787) began life in the 1920s to exploit Carboniferous Limestone for aggregate, and it received a huge boost when the M6 was extended northwards from Lancaster in the late 1960s. Its consent expires in 2023 but the owners hope to extend it to 2043. Currently, it produces aggregate, concrete and some building stone.

Hoff Quarry (NY6767,1800) has a single 10-m-high face and was worked in the late nineteenth century for crushed stone, but was abandoned by 1913. This quarry worked a type of rock called breccia, locally known as Brockram ('broken rock') composed of fragments of Great Limestone Member rock embedded in basal beds of overlying Penrith Sandstone. In this sense, Hoff is an unusual quarry.

Fossil-rich Yoredale Group Limestone was quarried in the Great Asby area of Westmorland for a short period in the 1830s and 1840s to be cut, polished and sold as marble. The marble mill (NY6855,1370) still stands but a contemporary source recorded that it 'proved unsuccessful ... as has also a marble mill which was erected here a few years ago, by John Hill, Esq'. It was an ill-conceived venture.[14]

Chapter 5

Quarrying Sandstone

Seat Quarry (SD7086,9674), below Baugh Fell, is one of many small and remote workings that exploited Silurian sandstone. It is no more than 1.5 m deep and was probably opened up for a specific building task in the valley below, in the late eighteenth or early nineteenth century. It is unusual for such a small working to have a surviving name.

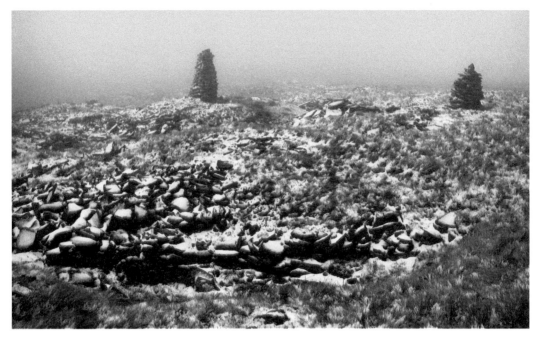

On the summit plateau of Baugh Fell, approximately 630 m AOD, Millstone Grit and Yoredale Group flagstone were worked in a series of shallow delphs, mainly in the early to mid-eighteenth century. Baugh Fell Quarry (SD728,925) presented stone-getters with challenging weather conditions, as when this photograph was taken.

At the northern end of the Howgill Fells, Hollybush Quarry (NY7098,0215), working Silurian Wenlock Sandstone, presented a very different challenge to its early nineteenth-century stone-getters – it is 2 km across rough moorland from the nearest decent track.

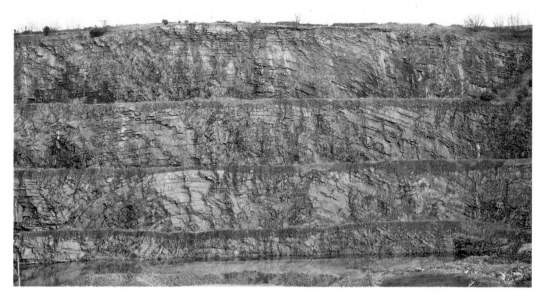

Silurian sandstone is still quarried from Coniston Group beds, which include a rock type locally known as Blue Rag. Holmescales Quarry (SD556,869) was a tiny working in 1858, abandoned by 1911 but re-opened in the later twentieth century as its stone is regarded as coming from among the best three quarries in Cumbria for high-grade roadstone. It is currently mothballed but the owners hope to be able to extend its footprint. This photograph highlights the complex folding of these beds.

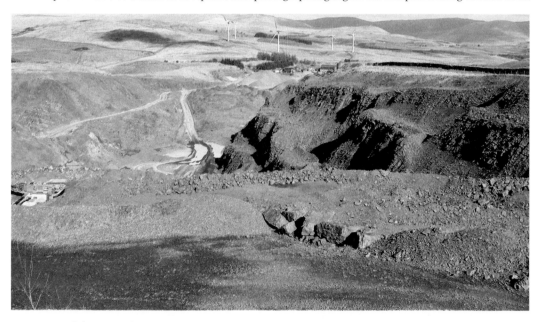

One of the other three high-grade roadstone quarries is Roan Edge Quarry (SD585,927), working Kirkby Moor Formation greywacke (hard-baked sandstone). Consent to work this site was granted in 1991 as the old quarry nearby was nearing exhaustion. Roan Edge Quarry itself has consent to 2038. This view looks across the older part of the quarry towards stocking grounds.

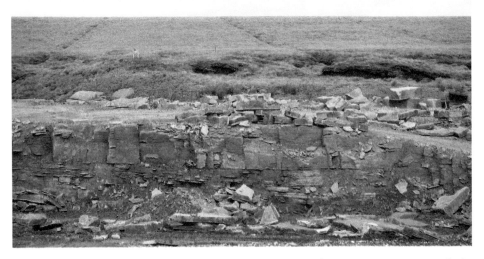

Flinty Quarry (NY771,416) is a source of dimension stone within Stainmore Formation beds. The stone is cut and dressed to produce building, roofing and paving stone, and it has consent to 2024. The 1859 OS map showed six roadways within the quarry leading to different sections of working face, and by 1890 it had doubled in area. All stone is won using a mechanical loader. This photograph shows how variable the thickness and quality of the beds are.

Black Syke (Old) Quarry (NY5747,5656) was leased out by Naworth Castle Estate, though from 1750 to 1838 it was worked in-house. Initially, it was very shallow and informal in nature and the ruins of a small cabin testify to its simple nature. Later, however, a long, narrow cut was driven into the hillside, enabling an open quarry to be developed to exploit Stainmore Formation sandstone for dimension stone: a tramway ran through the cut from a loading platform at the rear of the quarry. This photograph shows the overgrown cutting and a judd wall.

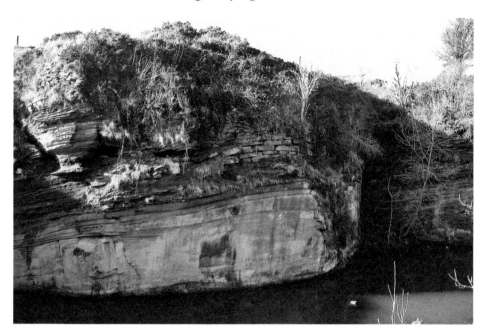

Hutton Roof Quarries (SD575,771) began as four delphs. By 1920 it had become a major operation, with eight buildings and a deep open quarry, which is now partly flooded. Stainmore Formation sandstone and siltstone were worked here until 1911–12 and from 1876 the quarries were noted for their 'Blue Flags' and grindstones. In this photograph details of the sandstone bedding are clear. A gruesome tale was reported in the *South Wales Daily News* and *Cardiff Times* in December 1894: a grindstone driller at Hutton Roof was knocked over by a falling block, which impaled him on his drill.

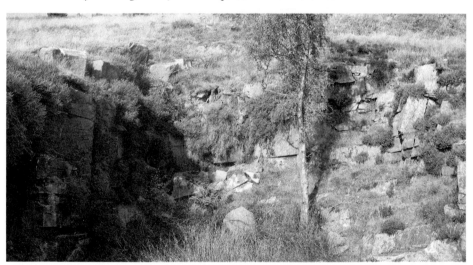

Penrith Formation sandstone beds have been exploited for centuries, mainly for dimension stone. Blazefell Quarries at High Hesket are composed of several delphs, some of which must have had hand-cranked cranes to lift stone out of the quarry holes, as at this 6-m-deep working (NY4942,4323).

Grinding stones were also roughed out on Blazefell, but how such heavy stone was transported away is a mystery as the ground can be so soft. This millstone and semi-dressed lintel lie where they were abandoned (NY49545,43311).

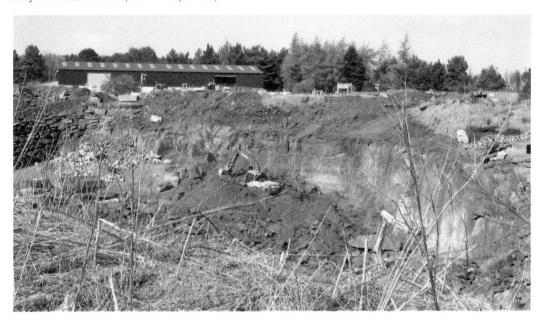

Most quarries producing Penrith dimension stone have long since been given up, but Bowscar Quarry (NY519,343) still produces decorative and dressed-stone products. It re-opened in 2006 after a period of inactivity and has consent to 2042. Much of Penrith was built using stone from the Bowscar area.

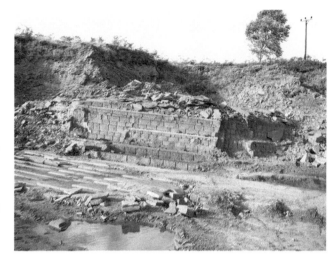

Nearby, Bowscar's sister quarry, the appropriately named Red Rock Quarry (NY5260,3482), was also given a new lease of life. Its thinly bedded flagstones, only a few centimetres thick, are riven here but dressed and finished at Bowscar.

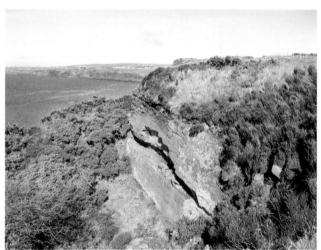

The St Bees area has long been famed for its high-quality red St Bees Sandstone beds, and numerous old quarries can be seen along the cliffs of St Bees Head. The only way to have lifted stone blocks out of them was by crane. In the eighteenth century much St Bees stone was sent over to North America as ship's ballast and used there for building. This old working (NX9582,1536) is one of several north of St Bees Head.

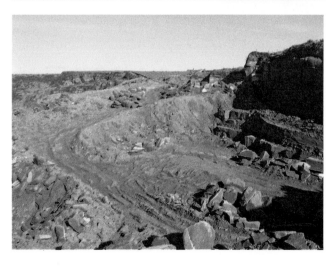

Birkham's Quarry (NX954,154) was worked through the nineteenth century, given up only to be revived *c.* 1980 to supply dimension stone that is sent to a stone yard in Dumfries for cutting and dressing, on an as-and-when basis.

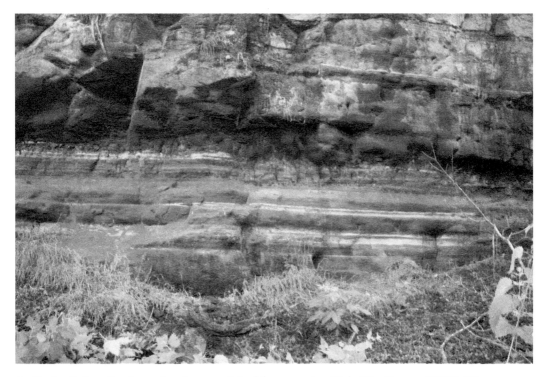

At Ousby, St Bees Sandstone has been exploited for centuries. Hole Sike Quarry (NY61,34) was opened up in the nineteenth century for local building work, but the stone proved too soft and easily weathered – not helped by the bands of white clay seen in this photograph – and so it was not used again.

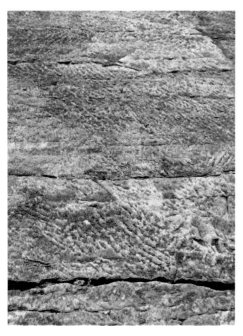

At Millbeck Bridge Quarries (NY691,248), St Bees Sandstone has been worked for centuries and some working faces have clear evidence of early – possibly medieval – tooling marks. In the eighteenth and nineteenth centuries the London Lead Co. used stone from here to build miners' housing in Dufton. These 600-m-long quarries, confined within a narrow gorge, have SSSI and RIGS protection, such is their importance geologically.

Chapter 6

Gypsum, Sand, Mudstone and Clay

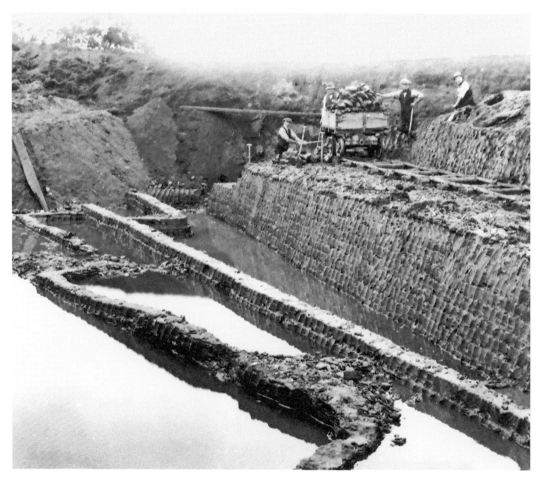

Where Triassic clays were accessible clay pits were opened up. Botcherby Clay Pit (NY425,559), on the northern outskirts of Carlisle, is shown here in 1922. The clay was cut by hand in layers and loaded onto bogies to be pushed to the brick and tile works. Botcherby was operative from 1832 to 1938. (CP17/071. Reproduced by permission of BGS © NERC. P202236)

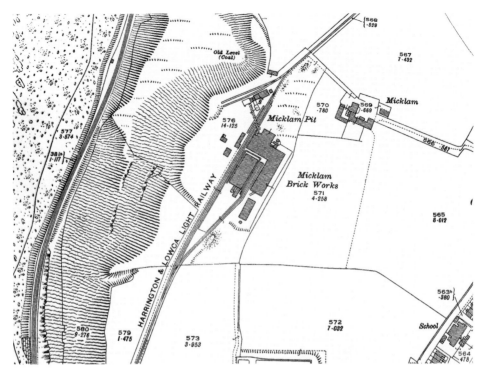

Bands of fireclay were exploited within Middle Coal Measures, as here at Micklam Brickworks (NY980,222). Micklam mainly produced refractory brick for iron and steel plants at Harrington (to 1921) and Workington. This extract shows the extent of the site in 1925. (OS 25 inch, Sheet LVI.10)

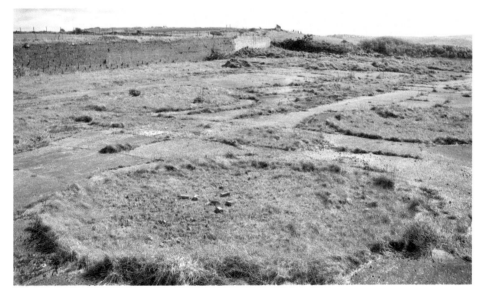

Micklam closed in 1976 and was later demolished. This image shows the 8-m diameter circular bases of the four beehive kilns which shared a centrally placed chimney.

Upper Coal Measures siltstone and mudstone were dug at Lambfield Tileworks (NY381,431). There were three pits and the works used a hand-operated pug mill to press the clay prior to moulding. Lambfield was active by the 1830s but closed in the 1860s.

Mudstone within the Eden Shales Formation was the raw material for large brick and tile works, especially at Cotehill where the Carlisle Brick and Tile Works (NY4680,5150), Cumwhinton Brick and Tile Works (NY4655,5164) and Crown Brick and Tile Works (NY4625,5172) operated in close proximity, each with rail loops off the main line. Carlisle closed in the 1920s and Cumwhinton by *c.* 1910. Crown (or Lonsdale Brickworks), whose flooded pit is shown here, was worked from *c.* 1885 to *c.* 1920, based on large continuous Belgian and Scotch kilns.

This staged image from *c*. 1899 shows a group of workmen at the Crown Works. (CAS Carlisle. DX50/1.0109170002)

Also staged in about 1914, this group of workmen stand with the drying sheds as a backdrop. (CAC Carlisle. DX 50/1.10917)

Altogether different in nature was surface quarrying of mudstone from the Stainmore Formation at Forest Head Quarry (NY584,574). This was a massive limestone quarry but the *riddings* – the mudstone overburden – shown here was stripped and sent by tramway to Kirkhouse Brick and Tile Works (NY567,598), between 1927 and the 1940s.

Mudstone in the Tarn Moor Formation was worked for a very short time in the mid-nineteenth century on Rosgill Moor near Haweswater. A tiny overgrown quarry (NY5260,1535) and this small building platform (NY5266,1532) are all that remain of a 'Slate Pencil Mill'.

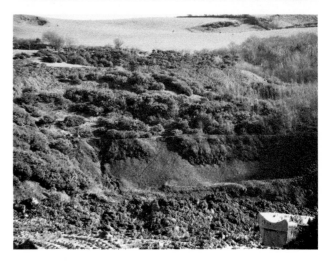

Skiddaw Group mudstone and shale have been worked for over a century to feed a Hoffmann brick kiln at Askam in Furness. The original water-filled pits lie south of the brickworks, but since 1969 shale has been dug from High Greenscoe Quarry (SD224,764), which has consent to 2028.

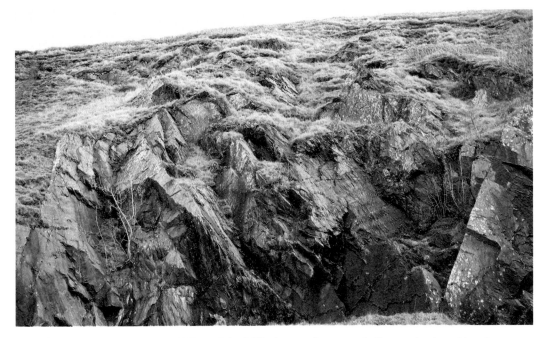

Rogerhowe Quarry (NY6139,0303) exploited Silurian mudstone and siltstone in the mid to late nineteenth century for crushed stone.

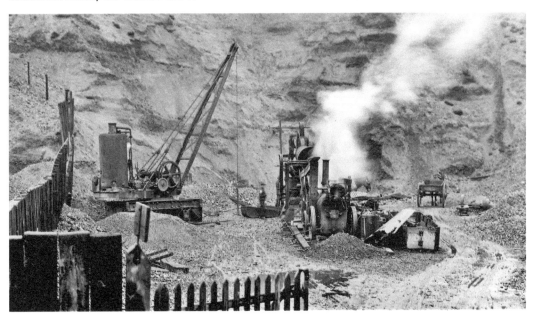

On the west coast, plain glacial sands and gravels overlying Lower Coal Measures proved a ready source of aggregate. Harrington Gravel Pits (NX9907,2501 and NX9914,2501), shown here in 1922, were worked from *c.* 1918 to *c.* 1939. Harrington was well equipped with a steam crane and a steam-powered crushing mill. Pony carts were the means of transferring crushed gravel out of the pit. Both are now infilled. (CP17/071. Reproduced by permission of BGS © NERC. P021269)

At Overby, Triassic sands and gravels have been quarried for at least a century, with several quarries still being operational. High House Quarry (NY126,470) began *c*. 1920 as a pit close to the road, but has grown massively, now producing graded sands and bulk aggregates.

Aldoth Quarry (NY133,480) is also still working, but not at the same scale as Overby.

In the Brampton area the Roman tradition of quarrying Triassic sandstones continues on a commercial scale in several large quarries, such as at Hollow Bank (Low Gelt) Quarry (NY523,586). This supplies material to the asphalt plant at Shap.

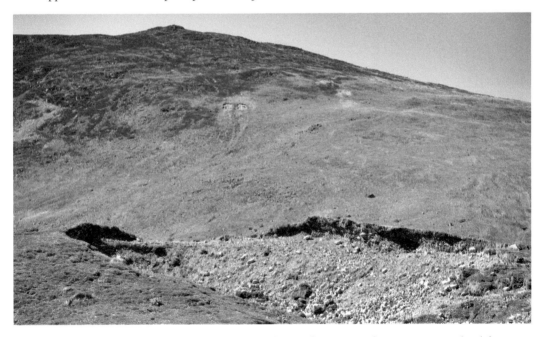

Long Hill Quarry (NY3537,3461) is typical of small gravel pits opened up on common land for local use. This one was cut into a glacial esker made up of coarse gravels, which were ideal for maintaining local tracks.

Permian evaporites in the Eden Valley have been worked in open quarries and mines since the mid-nineteenth century, initially for gypsum (alabaster) and later for anhydrite, which occurs at depth. High Stand Quarry (NY483,501) was working before 1860, but by 1900 had been abandoned. A tramway linked its two open quarries to the main line, passing through Knothill Plaster and Cement Works to the now disused Boaterby Quarry.

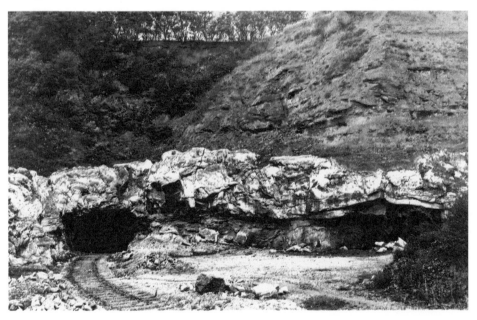

Gypsum quarrying at Cotehill is known from as early as 1685, but it only became a large-scale industry in the 1830s. Cocklakes alone had five discrete quarries but by 1922 exhaustion of accessible deposits led to the driving of tunnels into the hillside. Initially, gypsum was used to make alabaster statues and ornaments, and donkey stones for whitening doorsteps. This 1927 image shows a new level driven in at the base of an exhausted open quarry (NY452,507). (CP17/071. Reproduced by permission of BGS © NERC. P204089)

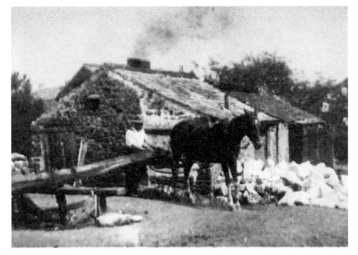

At one time or another there were fourteen discrete quarries at Kirkby Thore, where several small concerns had their own gypsum quarries and mills. This mill, photographed *c.* 1897, shows James Ellwood driving an edging stone at his rubbing-stone mill at Kirkby Thore. (BPB 1973)

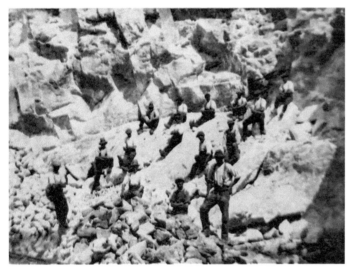

This view, in an unidentified gypsum quarry at Kirkby Thore, shows the *rockmen* taking a moment out from breaking stone blocks down to a more manageable size for loading on pony-hauled wagons. (BPB 1973)

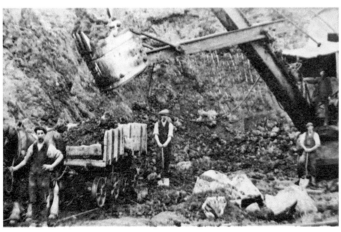

Potts Quarry, Kirkby Thore, used a degree of mechanisation, as seen in this 1914 image where a Ruston-Procter steam navvy is loading gypsum onto wooden wagons. (BPB 1973)

Chapter 7

Quarry Infrastructure

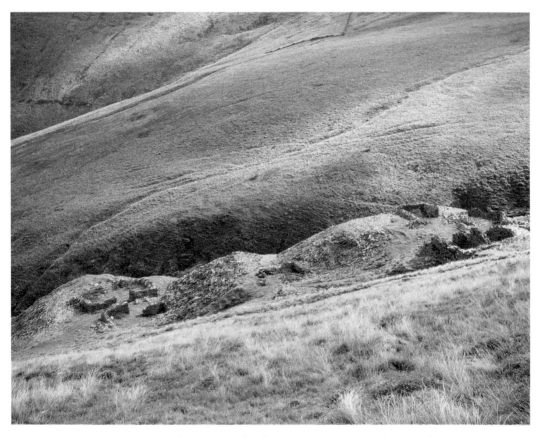

In most slate quarries, spoilheaps were levelled to create dressing floors with their open-fronted riving and dressing sheds and workmen's cabins. Here, at Caudale Quarry, two such facilities are seen.

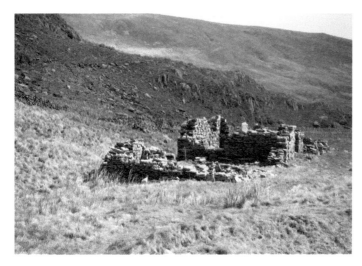

At Wrengill Quarry, this 33-m-long range housed an office, storeroom and workshops associated with its twentieth-century phase.

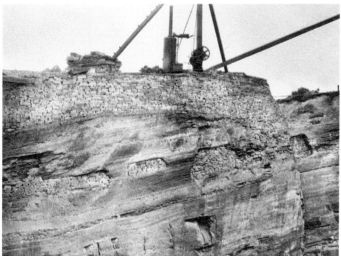

In 1909, this vertical face at Hutton Roof Quarries was reinforced with stone infilling and the top was levelled off to take the weight of the steam crane used for lifting stone blocks out of the deep quarry hole (*see page 53*). A flatbed bogie stands next to the crane. (Image part of British Science Association [formerly BAAS] collection, reproduced with permission of BGS. EA18/027. P247407)

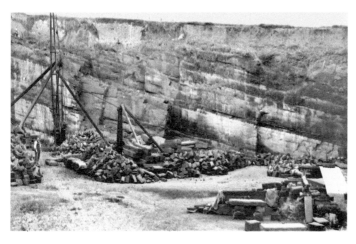

A large derrick crane and a hand-cranked *shear-leg* are seen here lifting and moving sandstone blocks in Chalk Quarries in 1935. (CP17/071. Reproduced by permission of BGS © NERC. P206517)

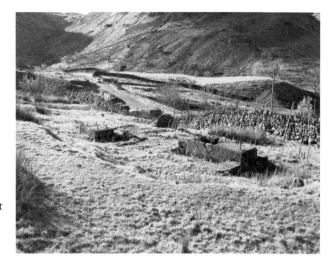

In its 1930s reincarnation, Caudale had a slate storage depot by the roadside with stacking platforms and the concrete bases of a loading gantry.

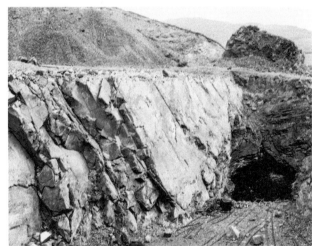

Tunnels allowed less weathered stone to be worked, and here, at Close Quarry (Embleton) in 1935, a tunnel with multiple tramway tracks appears to be out of use. (CP17/071. Reproduced by permission of BGS © NERC. EA18/027. P206570)

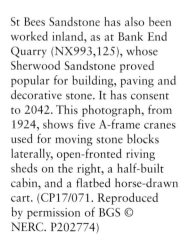

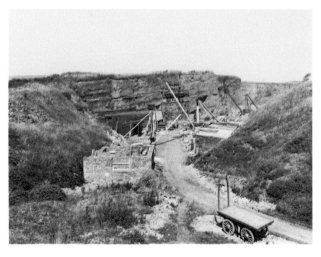

St Bees Sandstone has also been worked inland, as at Bank End Quarry (NX993,125), whose Sherwood Sandstone proved popular for building, paving and decorative stone. It has consent to 2042. This photograph, from 1924, shows five A-frame cranes used for moving stone blocks laterally, open-fronted riving sheds on the right, a half-built cabin, and a flatbed horse-drawn cart. (CP17/071. Reproduced by permission of BGS © NERC. P202774)

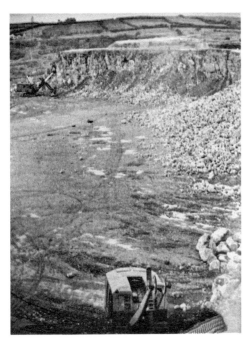

At Stainton Quarries, two navvies are poised ready to load stone into the company's fleet of four Foden FGC5 8-cubic-yard dump trucks. (MQE 26, 1960)

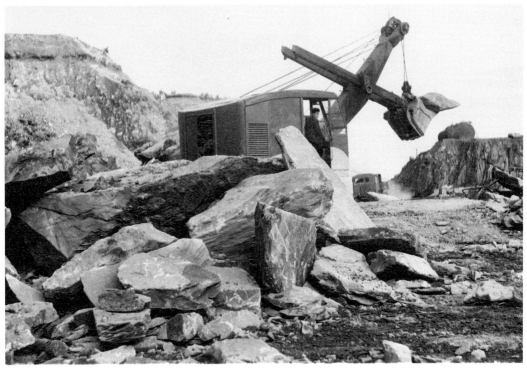

At Broughton Moor Quarry (SD253,945) in the 1950s, a mechanical shovel holds blocks of Tilberthwaite Formation andesite awaiting the approaching dump truck. (Reproduced courtesy of Museum of Lakeland Life and Industry, Lakeland Arts Trust, Kendal, 2002_7_219)

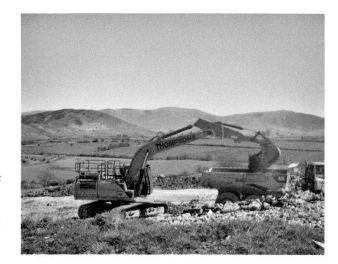

Today's crushed-stone quarries rely on state-of-the-art hydraulic equipment. At Moota Quarry (NY148,362), a Case CX300D excavator loads limestone into a 24-ton Volvo A25E articulated dumptruck.

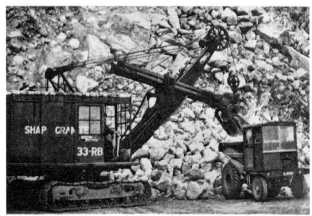

A Ruston-Bucyrus 33-RB loads granite blocks at Shap Pink Quarry onto the company's specially adapted dumpers. (MQE 25, 1959)

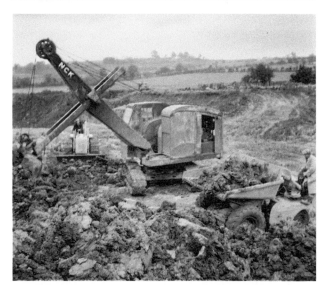

At Blencowe Quarry in the 1950s, an NCK shovel loads a dumper with overburden, assisted by a bulldozer. (CP17/071 BGS © NERC. P537814)

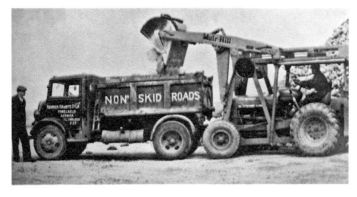

Threlkeld Quarry used two R-B shovels within the quarry, but used tractors modified by Muir-Hill to load stone from the stockpiles into its fleet of Ford Thames 7V 5-ton tipper lorries. This image is from the 1950s. (MQE 20, 1954)

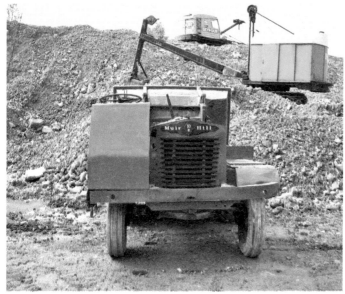

Threlkeld has an impressive collection of historical plant, including this Muir-Hill 10B dumper, a common sight in limestone quarries in the 1940s and '50s.

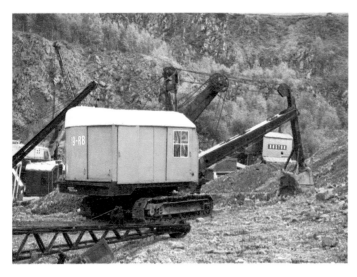

Threlkeld is home to the Vintage Excavator Trust, which possess this well-preserved 19-RB shovel, which is a mainstay of many quarries.

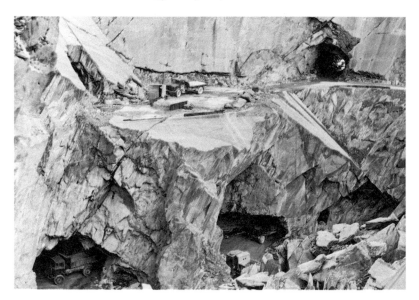

Broughton Moor was a complex of open and sub-surface workings, as seen here in the 1950s. On the lower level two dump trucks are loaded with stone on their way to the processing area, while a third is waiting to manoeuvre into position. On the upper level is a 1940s flatbed Bedford O-Series lorry: note the lack of protective bunding along the edge of this level. (Reproduced courtesy of Museum of Lakeland Life and Industry, Lakeland Arts Trust, Kendal, 2002_8_2604)

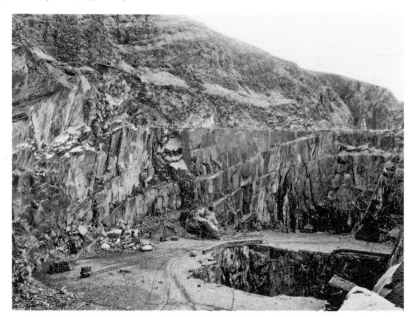

This 1935 view of Lord's Level, Kirkby Moor, shows bench working, with a flatbed *clog-bogie* fully loaded and another being loaded with undressed slate using a hand derrick. The tramway leads through a tunnel to the dressing floors. (Reproduced by permission of BGS © NERC. EA18/027. P206661)

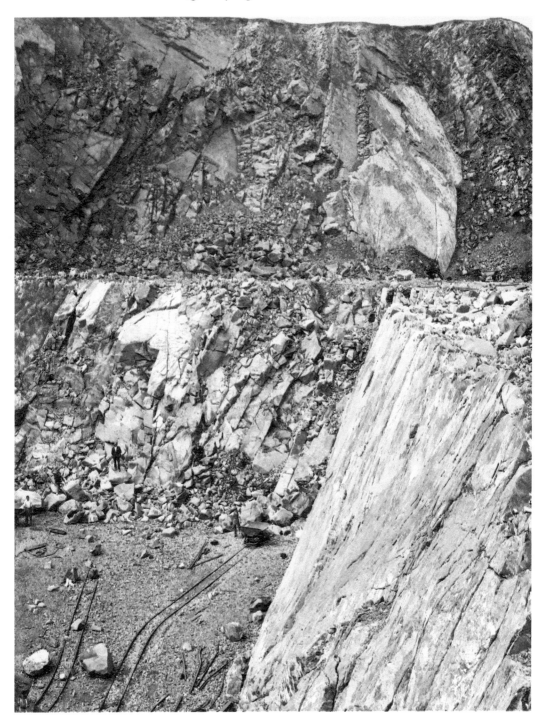

In Close Quarry in 1935, two men, *breakers and fillers*, are seen hand-filling Hudson V-skips with broken stone at the lower working face. (Reproduced by permission of BGS © NERC. EA18/027. P206572)

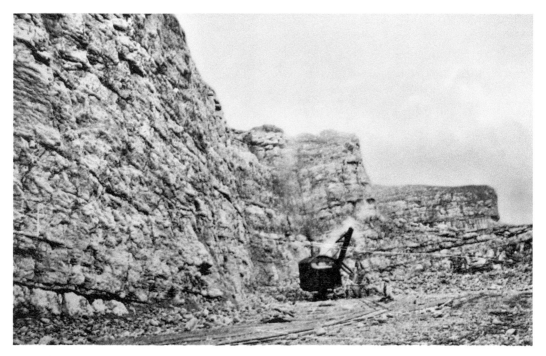

This steam shovel loading a V-skip with limestone at Rowrah Quarry is an early example of mechanisation. (MQE 1, 1936)

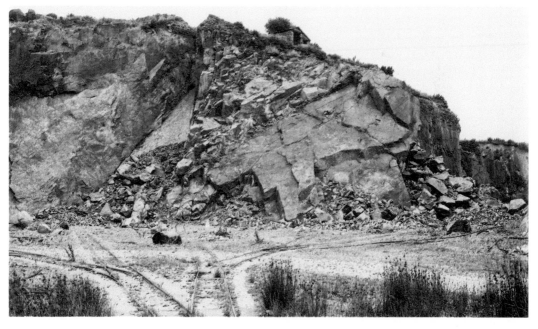

Most non-slate quarries used narrow-gauge Jubilee track and V-skips within the quarry. Here at Broad Oak Quarry in 1935, five tracks branch off; each had its own breaker and filler. (Reproduced by permission of BGS © NERC. EA18/027. P206635)

Every quarry using explosives needed a strongly built powderhouse sited well away from the quarry. This one is 250 m from the entrance to Midgeholme Quarry.

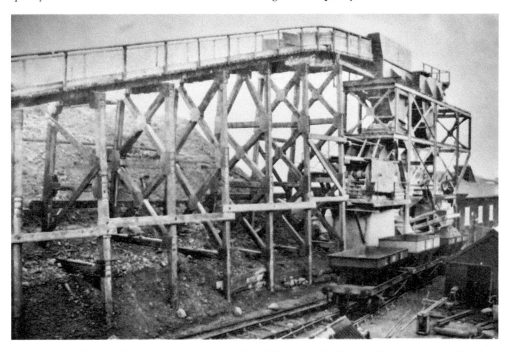

Aggregate and crushed-stone quarries needed bulk-loading facilities either at the roadhead or railhead. Seen here are the conveyor-fed loading hoppers at Rowrah Quarry. (MQE 1, 1936)

Chapter 8

Processing Stone

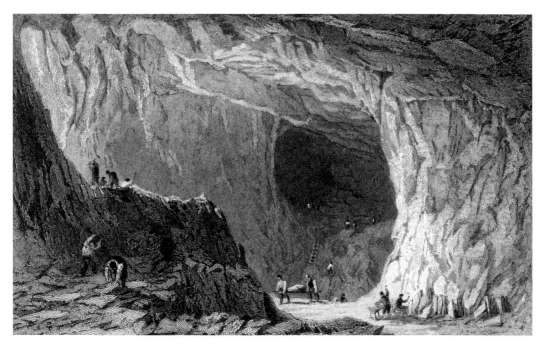

This engraving of a large cave-working at Thrang Quarry (NY320,056) shows several *rockhands* above the ladder, prising apart *clogs* (stone blocks): on the left, *dockers-up* are using picks, bars and a large *docking-hammer* to break clogs down; on the right, *clog-rivers* are using mallets and chisels, with one of them doing it on a wooden bench or *brake*; and two men are carrying a clog on a wooden stretcher. (*Thrang Crag Slate Quarry, Great Langdale, Westmorland, [the property of Lord Lowther]*. Engraved by William Alexander le Petit from an original study by the gifted Thomas Allom, 1832–35)

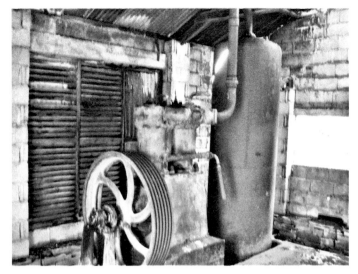

Spout Crag Quarry (NY307,051) worked from 1888 until recent times, exploiting Lingmoor Fell andesite for green slate. The source of power latterly was this Broomwade belt-driven compressor.

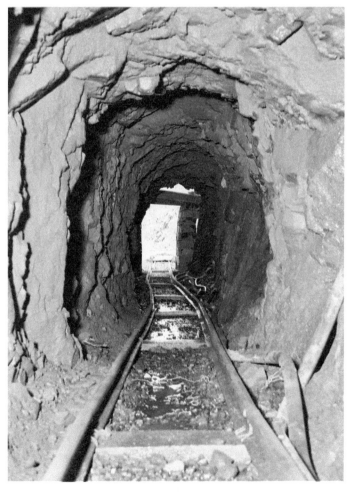

From the 1930s to 1950s, several large quarries used heading blasts to bring down up to 100,000 tons of stone per firing. T-shaped tunnels, like this one at Shap Blue Quarry, were driven into the face. In 1937 one was cut at Shap Pink Quarry 14 m in length with 14 m and 6.7 m cross-tunnels. The cross-tunnels were packed with black powder and the main tunnel was rammed and sealed to bring down 80,000 tons to meet a contract to supply stone for building London's Wandsworth Bridge. (CP17/071. BGS © NERC. P538816. 1950s)

Until *c.* 1800, rock was worked using a *nicking tool* to open out a line of small notches, as seen here at Smardale Bridge (NY7207, 0593). Iron *wedges* were driven into the notches to open out and split the beds. This little quarry was cut in Ashfell Sandstone beds for building the bridge.

To reduce the size of massive blocks, without unduly damaging them, the *plug-and-feather* method was used, largely replacing wedges. A line of holes was drilled, two iron feathers were inserted in each and an iron plug was hammered between them in sequence, cleanly splitting the block in two. Lifting chains are also seen here at Shap Pink. (MQE 25, 1959)

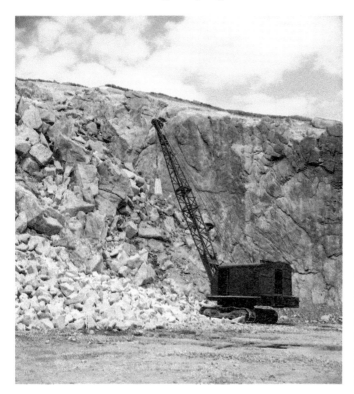

Where precision was not required, large blocks were broken up using a *drop-ball*, as here at Shap Pink in the 1950s. (CP17/071. BGS © NERC, P538824)

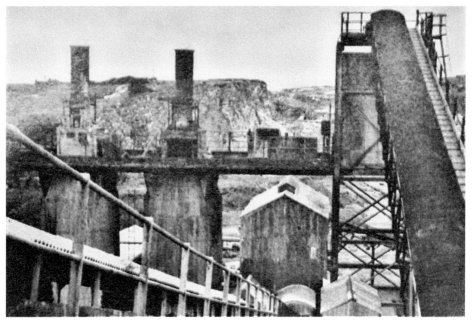

Various patent kiln designs were used in limestone quarries. Stainton Quarries had a twin battery of steel-clad 'Devon' kilns, commissioned in 1954, each yielding 164 tons of lime per week. (MQE 26, 1960)

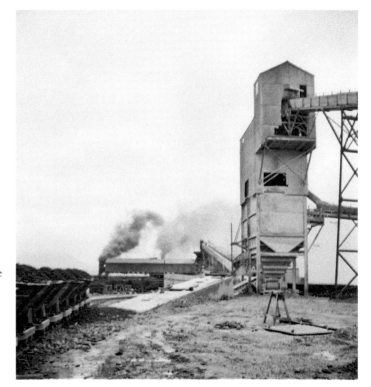

Harrison's Lime Works at Flusco had a battery of four Priest kilns until *c.* 1977. This 1950s image of the screening plant shows the smoking kilns in the background and a chain of side-tipping V-skips full of limestone. (CP17/071. BGS © NERC. P537848)

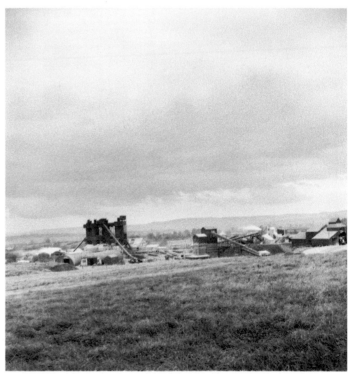

This view of Blencowe Quarry in the 1950s shows the crushing and screening plant on the right, with a dump truck backed into the open primary crusher shed, and a battery of four Priest kilns on the left. (CP17/071. BGS © NERC. P537816)

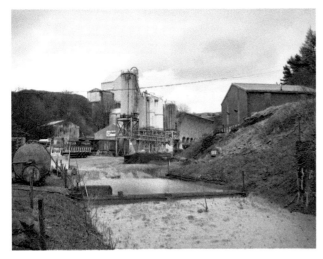

Hartley Quarry used modern kilns and the older masonry-built battery seen here. Nowadays, only the hydrating plant next to the old kilns is in production.

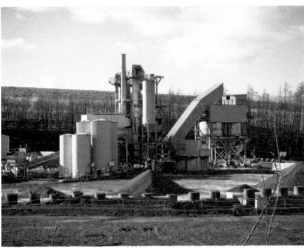

Shap Blue Quarry has a tar-coating plant, which was installed in 2009.

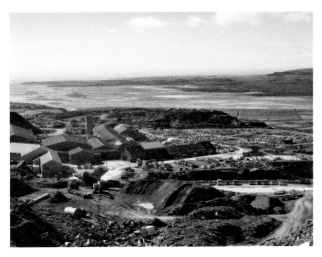

The scale of operations at Burlington Stone is illustrated by the extent of the stocking ground and processing sheds at Kirkby Quarries.

Chapter 9

Transporting Stone Products

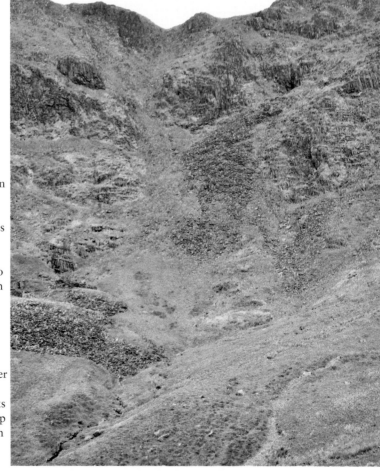

A few slate quarries in Cumbria are so high and inaccessible that using pack-ponies was impossible, and Star Crag Quarry is one such. The only way to move slate down such a precipitous slope was, in the words of a contemporary observer, 'by men, in *hurdles*, placed at their backs'.[15] In other words, they strapped a frame on their backs and ran down with up to 35 kg of slate, each day making multiple journeys.

At other quarries the gradient was easier but still too steep for ponies, so *trail-barrows* were used instead. Another contemporary observer described what he saw from the valley below as men from Caudale Quarry toiled away: 'A man will carry eight hundred weight [400 kg] at a time, and go faster with it than without it. The slate is laid upon a ... *Trail Barrow*; it hath two inclining handles, or *stangs*; between which the man is placed, going, like a horse, before the weight'.[16] He then had to haul it back up to the quarry each time.

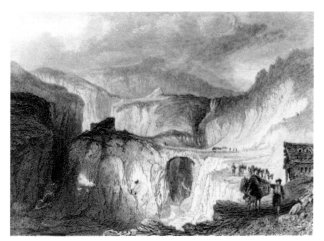

Where the descent was less hazardous, teams of pack-ponies carried slate downhill in panniers slung over their backs. This contemporary print at Wrengill Quarry illustrates the size (and weight) of their burden. They faced a journey on rough and stony tracks of many kilometres. (*Long Sleddale Slate Quarry, Westmorland*. Engraved by Joseph Wilson Lowry from an original study by the painter-architect Thomas Allom, 1832–35)

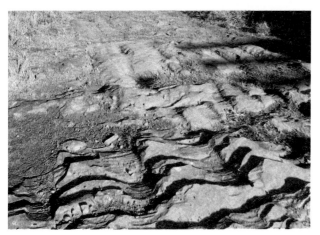

Around St Bees Head, sandstone blocks of varying size were carted away along the one cliff-edge track. Here, where it cuts through a rock outcrop, wheel ruts have been etched into the bedrock, emphasising the thousands of journeys that were made over the centuries.

At Chalk Quarries all the stone had to be taken away along the gorge bottom where the ground is soft, so this stone causeway was laid to stop carts sinking.

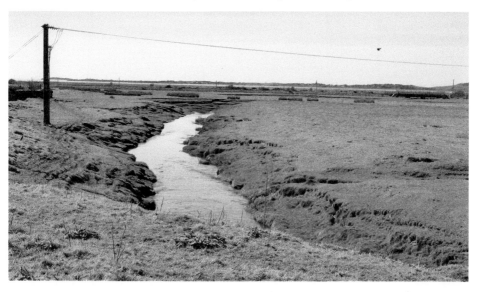

Once slate reached the lowlands it was sent by boat down Coniston Water or Windermere or the nearest navigable river. Much of the slate from Kirkby Moor Quarries was loaded onto flat-bottomed boats called *dolly flats* at Kirkby Pool 'Slate Depot', seen here, at the highest navigable point on the Duddon. This method was used from the late eighteenth century to the coming of the railway in the 1840s. The boats took their cargo down the estuary to Millom or Haverigg, where it was trans-shipped to sea-going sloops. From May 1737 to May 1738 one ship loaded slate at Kirkby Pool compared to thirteen at Angerton Point and sixteen at Greenodd Wharf on the Leven.

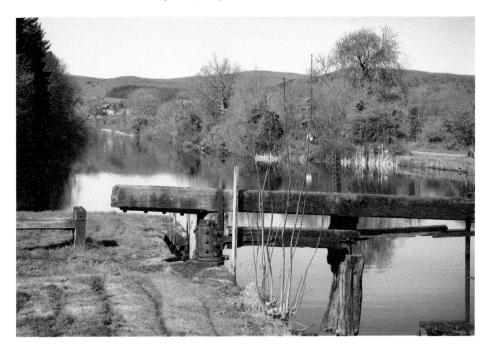

Much slate from Coniston, Gawthwaite and Kirkby Moor was carted to Ulverston to be loaded onto sloops heading as far as London, Hull, Edinburgh and Aberdeen. In 1828, 10,000 tons from Furness quarries were shipped out of Ulverston. The opening of the 2-km-long Ulverston Canal in 1796 shortened the road journey and catered for ships up to 350 tons.

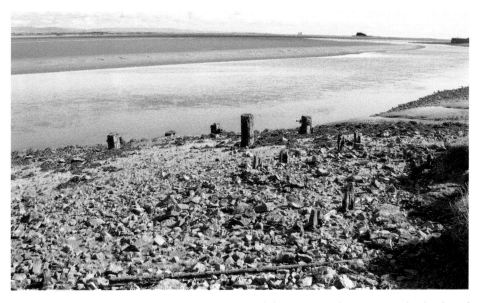

Limestone from Plumpton Quarries was shipped from a wooden pier on the banks of the Leven (SD3129,7827). All that remains now are the stumps of the wooden piles and lengths of tramway rail.

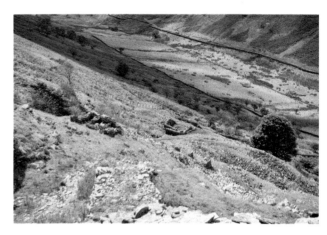

Where slate quarries were worked in cascading tiers on steep fellsides, inclined planes lowered slate to the dressing floors. At Troutbeck High Quarry, however, the slope was too steep, so an aerial flight was used instead.

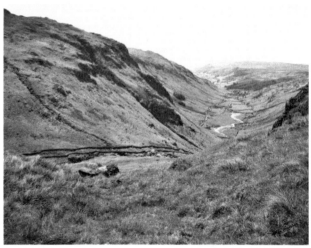

In the twentieth century, the slowness and expense of using pack-ponies or carts threatened the viability of remote slate quarries. Wrengill thought they had found the answer when they decided to install a long aerial flight from Steel Rigg to the valley floor. It was never built, however, as it came too late.

Much Kirkby Moor slate was sent down to the riverside depot on a 3-ft 2-inch-gauge inclined plane. Five full wagons descending hauled five empty ones back up, for 110 years until road transport replaced it in 1952.

Chapter 10

Afterlife

Barfs Sike Quarry (NY004,244) was a grouping of large Stainmore Formation limestone quarries. Up to 1879 a consortium led by Sir James Bain leased the complex, including nine lime kilns, supplying Bain's ironworks at Harrington. In that year they leased the quarries to two local railway companies. In 1871 Messrs Bain leased wayleave rights for a waggonway from the main quarry to the ironworks. All the quarries here have been infilled and restored to pasture and a golf course. Only the waggonway bed, seen here, survives of this major industrial complex.

Broughton Craggs Quarry (NY089,318) worked Second Limestone beds, initially for lime burning in the early nineteenth century as well as for 'Freestone of excellent quality' in the 1860s, when it was leased by Workman & Burton. In April 1897, when it was leased by Allerdale Coal Co., quarryman John Wood met his end when he was hit by a flying rock during a blast.[17] After closure it became an inert-waste landfill site, which has now also closed. The surface has been reseeded and trees planted to (successfully) encourage red squirrels. (OS 25 inch, Sheet LIV.3, 1898)

Little Langdale Quarries (NY313,028) were a complex of open quarries, closeheads and levels enabling maximum access to its best green slate, within Seathwaite Fell Sandstone. In 1929 they were purchased by Beatrix Potter, who gifted them to the National Trust, though quarrying continued on and off until *c.* 1951. It now has public access into the main Cathedral Cavern closehead, and twenty-five climbing routes.

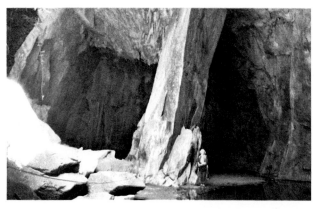

Clints Quarry (NY008,124) operated on a major scale from 1850 to 1930, burning lime for blast furnaces at Workington. It was linked to the main line railway by a 60-m-long tramway cutting, which branched into fifteen internal tramways. Proposals to use it as a landfill site *c.* 1980 were refused: it now has SAC, SSSI and LNR designations.

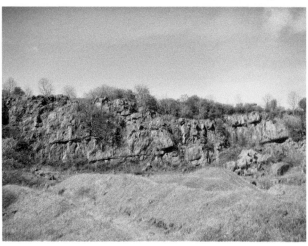

Cowraik Quarry (NY5415,3095) provided much Penrith Sandstone for the town's nineteenth-century building boom and, in 1819, was designated a public quarry under the Inglewood Enclosure Award. A planning application lodged in 1948 sought permission to continue extracting 200 tons of sand per year. It is now a geological SSSI and LNR.

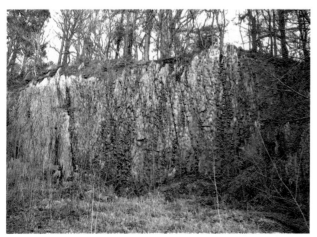

Eccle Rigg Quarry (SD2103,8675) has a remarkable 18-m-high sheer face with very rare examples of what are called 'sole marks' dating from the formation of these Silurian Gawthwaite Grits, wherein the beds were folded through 90 degrees. Nineteenth-century quarrying has exposed this most unusual geological feature and, known as Donkey Rock, it befits its RIGS status.

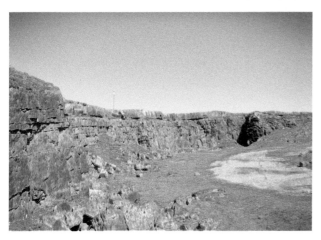

Faulds Brow Quarry (NY3035,4070) was worked for Yoredale Scar Limestone for roadstone and burning in two lime kilns in the eighteenth and nineteenth centuries. Because of its remote but accessible location, it became a haven for illegal off-roaders and fly tippers, despite having SAC and SSSI protection. The problems seem to be under control now.

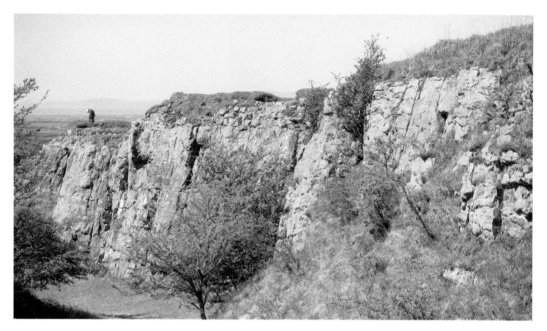

Another Yoredale limestone quarry is High End (High Head) Quarry (NY249,408), which had three kilns. The 1781 Ireby Enclosure Award set it aside as a public quarry, with the lime to be used to 'improve the grounds' – i.e. to improve soil quality. In 1949, David Johnston & Son of Brigham, quarry owners, applied for consent to erect crushing and screening plant and to expand the quarry. However, it is now maintained as a country wildlife site, though it is also a popular venue for novice climbers.

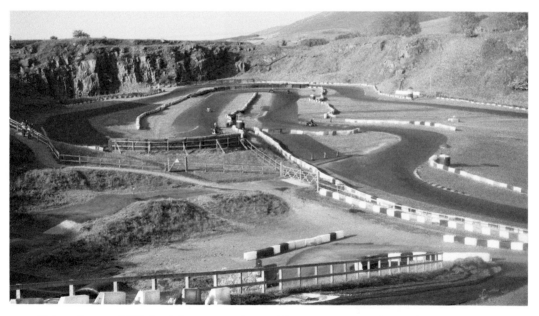

Kelton Quarry (NY068,183) was one of several large quarries working Eskett Limestone for use in West Cumbrian ironworks. It closed in 1950 and is now a popular karting venue.

Langrigg Quarry (NY648,260) was one of many quarries exploiting gypsum from the Eden Shales Formation. Joseph Robinson & Co. held the lease until 1910, when they declared reserves were almost exhausted. The three open quarries here have all been infilled and restored to agricultural use. The chimneys of British Gypsum are seen in the far distance.

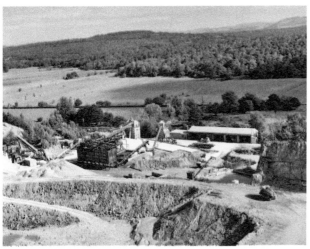

Middlebarrow Quarry (SD467,767) opened in the late nineteenth century to work beds of Carboniferous Limestone with a rail spur into the quarry to dispatch the huge quantities of crushed stone. In the 1950s Messrs Keirby & Perry operated the site, later known as Silverdale Quarry, and this view shows their processing plant. Since closure in 2000 it has slowly been regenerating as a nature conservation area. (CP17/971. BGS © NERC, P537917)

Stockhowhall Quarry (NY066,176) started as a tiny quarry feeding an on-site lime kiln, but grew exponentially in the later nineteenth century, developing into two deep quarries linked by a narrow rock cutting with an internal mineral railway. It closed in 1909 and has been left to slowly 'rewild'.

Notes

1. Fish, B. G., 'Towards a Strategy for Quarrying' (*Quarry Manager's Journal*, No. 57, 1973) pp. 275–80.
2. *Cumbria and the Lake District Joint Annual Aggregates Assessment, 2014*. https://www.cumbria.gov.uk/elibrary/Content/Internet/538/755/1929.
3. Cameron, D. G., Bide, T., Parry, S. F., Parker, A. S. and Mankelow, J. M., *Directory of Mines and Quarries* (Nottingham: British Geological Survey, 2014).
4. Johnson, D., *Quarrying in the Yorkshire Pennines: An Illustrated History* (Stroud: Amberley, 2016).
5. CAC Carlisle. D/LONS/L/5/4/33D/11. Scandale Fell.
6. West, T., *A Guide to the Lakes in Cumberland, Westmorland, and Lancashire* (Kendal: W. Pennington, 1812), p. 157.
7. Tyson, 1984 (see further reading).
8. David, 1987(see further reading).
9. Rose. T., *Westmoreland, Cumberland, Durham and Northumberland: Illustrated*, Vol. 3, No. 47 (London: H. Fisher, R. Fisher & P. Jackson, 1835), p. 197.
10. Mannex & Co. *History, Topography, and Directory, of Westmorland* (Beverley; W. B. Johnson, 1851), p. 304.
11. Briggs, J., *The Remains of John Briggs* (Kirkby Lonsdale: Arthur Foster, 1825), p. 189.
12. CAC Carlisle. DX 2003/1. Price List. Quarries, June 1933.
13. *Cement, Lime and Gravel* No. 27 (7), (1953), p. 312.
14. Mannex, P. J., *History, Topography, and Directory of Westmorland* (London: Simpkin, Marshall & Co., 1849), p. 139.
15. Green, W., *The Tourist's New Guide, Containing a Description of the Lakes, Mountains, and Scenery, in Cumberland, Westmorland, and Lancashire* (Kendal: R. Lough, 1819).
16. Clarke, J., *A survey of the Lakes of Cumberland, Westmorland and Lancashire* (Penrith: printed for the author, 1787).
17. CAC Workington. DWm7/275/2. Particulars of sale. Building land, limestone and freestone quarries. 18 November 1868.

Further Reading

Technical reports can be found online:
Strategic Stone Study: A Building Stone Atlas of Cumbria & the Lake District (Historic England, 2013).
Mineral Resource Information in Support of National, Regional and Local Planning: Cumbria & the Lake District: Resources and Constraints: Technical Report WF/01/02 (BGS, 2001).

For an overview of quarry archaeology:
Newman, P. (ed.) *The Archaeology of Mining and Quarrying in England* (National Association of Mining History Organisations: Matlock Bath, 2016, *passim*).

For a geological perspective:
Marr. J. E. *The Geology of the Lake District* (Cambridge: Cambridge University Press, 2015).
Moseley, F. (ed.) *The Geology of the Lake District (*Yorkshire Geological Society Occasional Publication No. 3, 1978).

For aspects of quarrying in greater depth:
Cameron, A. D. *Slate from Honister* (Alston: Cumbria Amenity Trust Mining History Society, 1993).
Cameron, A. D. *Slate from Coniston* (Alston: Cumbria Amenity Trust Mining History Society, 2005).
Cameron, A. *Slate Mining in the Lake District* (Stroud: Amberley Publishing, 2016).
David, R. 'The Slate Quarrying Industry in Westmorland Part One: The Valleys of Troutbeck, Kentmere and Longsleddale' (*CWAAS* 87, 1987), pp. 215–35.
David, R. and Brambles, G. W., 'The Slate Quarrying Industry in Westmorland Part Two: A Field Survey of Selected Sites in Troutbeck and Longsleddale' (*CWAAS* 92, 1992), pp. 213–27.
Davis, E. and Davis, S. B., *Draining the Cumbrian Landscape* (*CWAAS* Research Series XI, 2013).
Geddes, R. Stanley, *Burlington Blue-Grey. A History of the Slate Quarries, Kirkby-in-Furness* (Privately published, 1975).
Jenkins, D., *The History of BPB Industries* (London: BPB Industries, 1973).
Tyson, B., 'The Troutbeck Park Slate Quarries, their Management and Markets, 1753–1760' (*CWAAS* 84, 1984), pp. 168–90.

Index of Sites